LEGENDARY L

— OF —

MILL VALLEY

CALIFORNIA

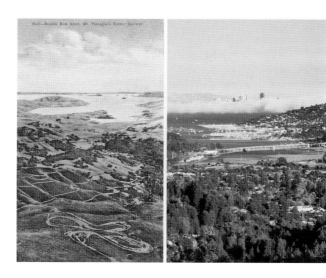

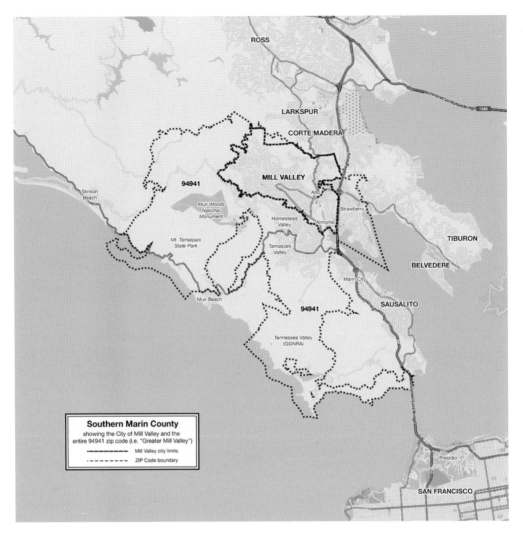

Greater Mill Valley

This map shows the borders of the incorporated City of Mill Valley as well as the border of "Greater Mill Valley"—the entire area with a "Mill Valley, CA 94941" address. The town of Mill Valley is almost always considered to be the "greater" definition. (Author collection.)

Page 1: Panoramic Views of Mill Valley

These side-by-side images show the same panoramic vista of Mill Valley in different eras. The c. 1903 postcard features the "The Crookedest Railroad in the World," which wove its way to the top of Mount Tamalpais until 1929. The view 110 years later includes significantly more trees and homes, a bridge across an inlet off Richardson Bay, and a fog-enclosed skyline of San Francisco. (Author collection.)

LEGENDARY LOCALS
OF

MILL VALLEY
CALIFORNIA

JOYCE KLEINER

Legendary Locals is an imprint of Arcadia Publishing
Charleston, South Carolina

Printed in the United States of America

Library of Congress Control Number: 2013946560

For all general information, please contact Arcadia Publishing:
Telephone 843-853-2070
Fax 843-853-0044
E-mail sales@arcadiapublishing.com
For customer service and orders:
Toll-Free 1-888-313-2665

Visit us on the Internet at www.arcadiapublishing.com

Dedication
To my husband, Robert, and son, Jake, with gratitude for their patience and support
And to Deborah Lichtman, my mentor and my friend

On the Front Cover: Clockwise from top left:
Jon Fromer, Elbert Robinson, and Dave Fromer, 1960s folk trio Jonathan, David, and Elbert (Courtesy of Jacki Fromer; see page 97), Sammy Hagar (right), rock musician (Courtesy of John Goddard; see page 93), Jacob Gardner, civic leader (Courtesy of Anne T. Kent Room, Marin Free Library; see page 15), Charlie Deal, toilet-seat guitar maker (Courtesy of Joseph Greco; see page 94), Dipsea runners, 7.5-mile Dipsea Race (Courtesy of Skip Sandberg; see page 68), guests of Dr. John Cushing's early-era spa, "Blithedale" (Courtesy of Anne T. Kent California Room, Marin County Free Library; see page 18), Ann and Dick O'Hanlon, artists (Courtesy of O'Hanlon Center for the Arts; see page 36), Jenny Fulle, subject of controversial women's rights battle (Courtesy of Jenny Fulle; see page 83), Suey Kee, early Mill Valley business owner (Courtesy of Marin History Museum; see page 17).

On the Back Cover: From left to right:
Katharine and Ned Mill and the staff of the *Mill Valley Record* (Courtesy of Suki Hill; see page 85), John Goddard (right), former owner of Village Music (Courtesy of Suki Hill; see page 89).

CONTENTS

ACKNOWLEDGMENTS

When I was invited to write this book, I felt both excited and intimidated. How could I tell the complete story of all Mill Valley's legendary locals? Of course, I couldn't. But I could create a scrapbook of moments to suggest the richness and diversity of the people who have made Mill Valley the town that it is. In my research, I met many of those people. They generously gave of their time to tell me their stories, or the stories of those who are gone. These conversations took place in cottages, apartment buildings, stately Craftsman homes, and more than a couple of converted barns, allowing me a greater understanding of my community.

I appreciate every person who shared a tale or trusted me with an irreplaceable document or photograph. But a few people—including members of Mill Valley's Historical Society—deserve special recognition for clarifying important events or complicated topics for me. They are Andy Berman, Betsey Cutler, Doug Ferguson, Bob Flasher, Kathleen Foote, John Goddard, Betty Goerke, John Leonard, Cindy McCauley, Elizabeth McKee, Steve McNamara, Joan Murray, Mary O'Leary, Chuck Oldenberg, Trubee Schock, Anne Solem, Dick Spotswood, Kim Strub, Jean Symmes, Abby Wasserman, and Ryan White.

Many thanks to the Anne T. Kent California Room, Marin County Free Library; the Bancroft Library, University of California, Berkeley; and the Marin History Museum for providing archival photographs, and to the professional photographers who allowed me to use their images—particularly Suki Hill, whose extraordinary talent for capturing the essence of Mill Valley's people with her camera cannot be overemphasized. Those who have provided images are acknowledged in the courtesy line following each caption. Photographs taken by me as well as images from my personal collection are noted as "author collection."

Thanks, also, to Matt Schriock of Image Flow in Mill Valley for helping me gain control of my camera and my collection of images. And finally, my deepest gratitude goes to Deborah Lichtman for her guidance and support throughout the writing of this book.

While I have made every effort to achieve accuracy here, there still may be disputed details. Any errors in this book are my responsibility and are in no way a reflection on those whom I have consulted or interviewed.

INTRODUCTION

The story of Mill Valley begins with Mount Tamalpais, standing more than 2,500 feet above sea level and separating Mill Valley from the Pacific Ocean. Long before the first Coast Miwoks arrived in the area, the mountain shaded the canyons below it and served as a buffer from the coastal wind and fog. The Miwoks did not live on the mountain itself, but Mount Tamalpais was surely a symbol to them, as it would be for those who came later.

After the first white man arrived in the area, the story of Mill Valley's early residents describes a shifting control of the land. Three separate countries governed the area between the 1700s and the turn of the 20th century: Spain, Mexico, and the United States. During those early years, the area was molded by the impact of nearby missions, a Mexican land grant system called ranchos, gentleman farmers, tenant-ranchers, land speculators, and entrepreneurs. For some, fortunes would be lost. For others, a new and better life would begin.

Location has blessed Mill Valley in ways no one could have predicted in those early years. To the south of what is now Mill Valley—in San Francisco, and to the north of it—in San Rafael, large missions were built, providing the foundations for future towns. But the area just north of the growing harbor town of Sausalito stayed relatively undisturbed. Its position on the north side of the then bridgeless bay insulated it from changes taking place elsewhere in the state right up to the 20th century.

By 1890, San Francisco was a sophisticated metropolis. Many city dwellers took a ferry across the bay to escape—not the heat and humidity of the big city—but the bone-chilling fog. They also enjoyed the splendors of hiking on Mount Tamalpais and the joys of "country life," whether as guests at the fashionable Blithedale Hotel or in more modest accommodations.

When the opportunity to own a parcel of this paradise presented itself in the form of a land auction in 1890, many San Franciscans took advantage of the opportunity. Most buyers built modest summer cottages; some built vacation estates. And a hardy few settled in to build a new life in full-time homes. Among them were immigrants from the Portuguese Azore Islands, who had formerly been tenant-farmers on the land. Mill Valley entered the 20th century as a relatively pristine and rural landscape.

Contrary to its name, Mill Valley never served as a mill town. There is no evidence that John Reed's mill, built around 1837, did much more than hone timber for Reed's relatively modest lumber needs and those of a few neighbors. Mill Valley was not a logging town for its residents, either. Outsiders logged its vast forest of virgin redwood trees and floated the logs to Sausalito, where they were either milled or carried on to other parts. And though the immigrants from the Azores began what remains a tradition of dairy ranching in Marin County, Mill Valley was never a farming or a ranching town on a significant scale. Mill Valley was an outpost. Later, it was a retreat. Eventually, it became a residential community.

The San Francisco earthquake and fire of 1906 turned some part-time summerhouse owners into permanent residents. And when the Golden Gate Bridge opened in 1937, the census numbers grew again. But it was not until GIs returned from World War II that Mill Valley saw a dramatic jump in its population, due mostly to the newly built tracts of houses springing up on former pastures.

Almost from the beginning, Mill Valley has welcomed progressive thinkers. The fact that the town voted Republican into the second half of the 20th century may seem to contradict that image, but Mill Valley's earliest residents identified themselves as "Progressive Republicans," a group who championed, among other things, conservationism and the vote for women. In fact, Mill Valley's story is rich with examples of true visionaries, and its continuing natural beauty and forward-thinking ideology are testaments to those people. Whether the vision was better government, parks and open spaces, quality housing for the town's seniors, or a beautiful new plaza for people to congregate as a community, Mill Valley has always included citizens who saw the possibilities.

And then there were the bohemians. As the metaphoric and literal landscape of the area changed, artists, writers, and philosophers took up residence in the farmhouses and abandoned barns they found to rent or buy. And there they remained, creating art and discussing their ideas with like-minded souls. Even before famous members of the Beat Generation like Alan Watts and Gary Snyder had moved into the cabins and other rustic shelters in Mill Valley's hills and canyons, many residents were seeing the world through unconventional lenses. After the first "Be-In" took place in Golden Gate Park in 1967, Mill Valley, with its pockets of alternative lifestyle communities, attracted many spirited nonconformists. By the 1970s, the word "funky" joined adjectives like "quiet" and "sedate" to describe the town.

High among those things Mill Valleyans value most is nature—particularly Mount Tamalpais. They also prize their proximity to San Francisco; the arts; political and social activism; wellness, and living with gusto; and heritage. Mill Valley may have been founded by people seeking a fresh start, but its citizens are as proud of their traditions and rich history as any New Englander.

Incorporated in 1900, today the "City of Mill Valley" (its official title) is a cul-de-sac; its northwestern-most address is more than five miles from Highway 101. Drivers do not pass through the City of Mill Valley on their way to any other town. It is only a destination. Unincorporated "Greater Mill Valley"—the entire area with a "Mill Valley, CA 94941" address—expands across former dairy ranch land. It includes the county-managed residential communities of Almonte, Alto, Homestead Valley, Strawberry, and Tamalpais Valley. It also covers Muir Woods National Monument, Mount Tamalpais State Park, and a number of county-governed areas of open space, all connected by an extensive trail system that draws Mill Valleyans out-of-doors 12 months a year. And just a short drive across the Golden Gate Bridge is San Francisco.

A woman visiting her daughter in Mill Valley once complained that it was impossible to know where the "good neighborhoods" were in the town. This statement is delightfully true. As would-be landed gentry and retired dairy farmers divided their property, those of more modest means took up life on the sold-off parcels and in the modest houses built between the estates. People live in restored barns literally steps away from grand mansions, and the tract houses were built beside scenic estuaries or forested parks, often within view of Mount Tamalpais. As a result, no one feels that their home is on the wrong side of the tracks.

Modern Mill Valley is not without its challenges. With at least 50 percent of Marin County land permanently protected from development, Mill Valley's real estate prices escalate significantly every year. This puts home ownership out of reach for too many of the kind of people who originally gave the town its character. But if past leadership is any indication, there is every reason to be optimistic that solutions to this complicated issue will be found.

The tales of Mill Valley's people meander and crisscross over generations much like the town's steps, lanes, and paths. Eventually, one person's story interconnects with another's, forming the intricate and rich weaving that is the town.

Mill Valley's citizens cannot take credit for the town's temperate weather and proximity to San Francisco, the Pacific Ocean, and the High Sierras. But they deserve recognition for protecting its natural beauty and its charming streets and parks, for creating its cultural attractions, and for supporting its outstanding public schools. To many visitors, Mill Valley can seem too good to be true. And perhaps it is. But even as citizens express concerns over changes, they admit that their hometown remains uniquely wonderful. And when a Mill Valley teacher put verse to music in praise of the town's virtues, the citizens made it Mill Valley's official song.

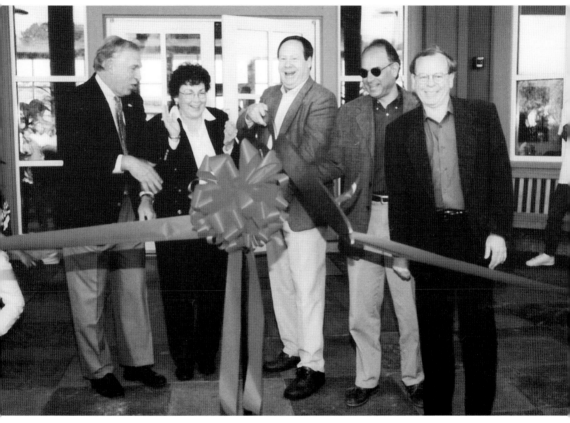

Mill Valley City Council
In 2001, city council members (from left to right) Dick Swanson, Anne Solem, Cliff Waldeck, Dennis Fisco, and Chris Raker cut the ribbon for Mill Valley's new community center. (Courtesy of Mill Valley Community Center.)

Mill Valley
by Rita Abrams

I'm gonna talk about a place
That's got a hold on me,
Mill Valley
A little place where life
Feels very fine and free,
Mill Valley
Where people aren't afraid to smile
And stop and talk with you awhile,
And you can be as friendly
As you want to be.
Mill Valley!
Talkin' 'bout Mill Valley,
That's my home!
It looks as pretty in the rain
As in the sun,
Mill Valley
And there's a mountain
That belongs to ev'ry one,
Mill Valley
And there are creeks
That run on endlessly,
And trees as far as you can see
It makes you feel as if
Your life has just begun.
Mill Valley
Talkin' 'bout Mill Valley,
Talkin' 'bout Mill Valley, California,
That's my home!
I know that there may come a time
I'll have to leave Mill Valley,
And ev'ry memory
Will seem like make-believe Mill Valley
And all the good things
That are mine right now,
Will call to me and ask me how
I could have left them all behind
How could I leave Mill Valley,
Talkin' 'bout Mill Valley,
Talkin' 'bout Mill Valley, California,
That's my home!

Downtown Mill Valley
In 1969, while seated on a bench in downtown Mill Valley, Rita Abrams was inspired to write a song about the town. In 1982, the downtown got an actual plaza, which is a popular gathering spot. (Author collection.)

CHAPTER ONE

From Footprints to Train Tracks

An inventory of Mill Valley's avenues, parks, and schools is instructive. There is no Broadway or Main Street, no Central Park, no Lincoln Elementary School or Woodrow Wilson High. Instead, one will find shorthand for the people who figure into Mill Valley's story: Miller, Throckmorton, and Blithedale Avenues; Old Mill Park; Edna McGuire Elementary School; and Tamalpais High School. Though the occasional street is named after a former president or war hero, more have been given the first names of the daughters and sons of early Mill Valleyans: Hilarita, Ethel, Lytton, Ralston. All across Greater Mill Valley, names like Dias Ridge and Reed Street pique an interest in a longer tale.

The first nonindigenous people of Mill Valley's early years came there with no past, or at least no past that mattered. Who they may have been, or whom they knew in Ireland, England, Portugal, or Spain, had little impact on what would become of them once they sailed into the San Francisco Bay. The objective for these settlers was to stake a lasting claim on land and to make the most of the possibilities they had been granted. For those who had no land, the goal was finding other opportunities. Later, when wars divided Spain from Mexico and then Mexico from California, the challenge would be to hold on to the life they had built.

California became a state in 1850, followed by industrialization and the railroad toward the end of the 19th century. Some saw this as yet another opportunity, others as the end of a way of life. Both were right.

Stories of Mill Valley's first people have been passed through the generations like folktales, and local historians debate the details. But there is no question that these early residents built the town's foundation, and they are the first of many names that should not be forgotten.

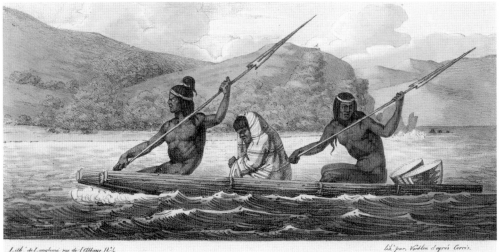

Bateau du port de S.ⁿ Francisco.

Chief Marin, Mill Valley's First Legend

The Coast Miwok Indians had lived in what is now Mill Valley for thousands of years before the Spanish first dropped anchor in the San Francisco Bay. They lived lightly on the land, with a diet rich in fish and shellfish from the bays, estuaries, and ocean. Years after the last Miwok had moved on, evidence of those communities could be found in mounds of discarded shells. These shell mounds helped archeologists identify the sites of former Miwok villages, including a significant site around the Tamalpais Park neighborhood of Mill Valley. This site is considered the likely location of the village Anamas, the home of an important Miwok named Huicmuse.

Huicmuse's story includes elements of both truth and legend. He was baptized "Marino" at Mission Dolores in 1801, and he learned the missionaries' language. His ability to speak their language, combined with his expert skills at navigating the waterways in his tule-reed boat, made him a valuable guide. He seems to have been respected by both the Spanish and the Native Americans, but other elements of his story have a mythological quality, leaving certain questions unanswered: was he actually a tribal "chief"? (More modern studies of how the Miwoks lived suggest a less hierarchical community.) Did he bravely climb Mount Tamalpais, despite Miwok folktales of evil spirits dwelling there? Did he defy the Spanish rulers?

After California achieved statehood in 1850, the former Mexican commandant Mariano Vallejo proposed that the region north of the bay be named after the Miwok chief "Marin," who had led resistance against the Spanish military. The legend of "Chief Marin" had thus begun. (Above, courtesy of Bancroft Library, UC Berkeley; below, author collection.)

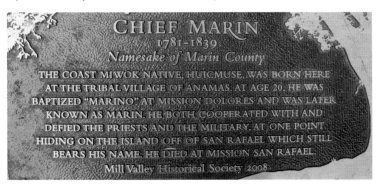

CHIEF MARIN
1781–1839
Namesake of Marin County
THE COAST MIWOK NATIVE, HUICMUSE, WAS BORN HERE
AT THE TRIBAL VILLAGE OF ANAMAS. AT AGE 20, HE WAS
BAPTIZED "MARINO" AT MISSION DOLORES AND WAS LATER
KNOWN AS MARIN. HE BOTH COOPERATED WITH AND
DEFIED THE PRIESTS AND THE MILITARY. AT ONE POINT
HIDING ON THE ISLAND OFF OF SAN RAFAEL WHICH STILL
BEARS HIS NAME. HE DIED AT MISSION SAN RAFAEL.
Mill Valley Historical Society 2008

The Reed Family, from Rancho to Town

In the early 1800s, two men—William Richardson and John Thomas Reed—sailed into the San Francisco Bay. Though they arrived in different years, their lives paralleled each other in significant ways.

Irishman John Reed arrived in the area as a sailor in 1826, but not before spending five years in Mexico, where he learned Spanish. His knowledge of Spanish, combined with his early friendship with Presidio commandant José Antonio Sanchez, and his Catholic heritage, situated him favorably with the newly formed Mexican government. In 1828, the new government began allotting enormous land grants, or "ranchos." The first Marin land grant went to John T. Reed in 1834. In 1836, Reed married Sanchez's daughter Hilaria. Reed honored the many provisos stipulated in the land grant: he did not divide or mortgage the land, he built a house within the first year, and he planted orchards. He also ranched livestock and horses and bought a boat that he used to ferry the supplies that he sold to the presidio. Among those supplies were redwood logs taken from his rancho, aptly named El Corte de Madera del Presidio ("the Cut Wood of the Presidio"). Reed also built a mill. Whether he built this mill to create lumber for his own use or for the presidio is unclear. But the mill never produced any significant income for the area, and in future years, a mill in Sausalito would replace any income that Reed's mill might have generated.

John and Hilaria enjoyed only seven years of marriage before John died in 1843. Hilaria, a widowed mother of four (John, Richardo, Hilarita, and Maria Inez), was to face a series of wars, territorial disputes, and a history-changing gold rush. By the time California became part of the United States, much of her land had been seized by the government or sold by those claiming to represent the Reed family interests. Ahead was a legal land battle that would go as far as the US Supreme Court and still not get resolved, while the land went fallow and became populated with gold rush squatters and cattle rustlers. Hilaria died in 1868. Though a portion of her land did eventually become undisputed Reed property, her heirs continued to fight land-title disputes as late as 1895. Today, half of Mill Valley is on land that was once El Corte de Madera del Presidio. The descendants of Hilaria and John T. Reed—many of which are pictured in the photograph here—extended into the 20th century. And despite the tumultuous land wars that defined their early heritage, they went on to make many important contributions to the community. (Courtesy of Anne T. Kent California Room, Marin County Free Library.)

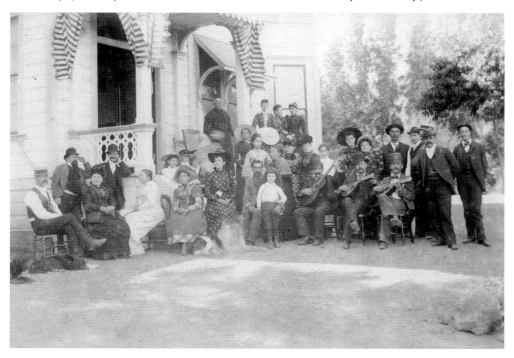

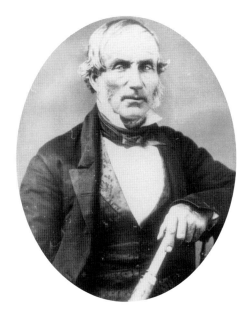

William Richardson, Fortunes Found and Lost

William Richardson sailed into San Francisco Bay in 1822 as the first mate of a whaling ship. Just as with John Reed in 1826, London-born Richardson soon found himself a guest in the home of a presidio commander, Ignacio Martínez. Richardson—like Reed—married the Presidio commander's daughter. In 1825, Richardson married Maria Martinez, and in 1841, the Mexican government gave Richardson a grant to Rancho Saucelito, a parcel of land covering more than 5,000 acres. This property included nearly half of the remaining land that would one day become Mill Valley. (But not all the land. A relatively small plot of unassigned land is the site of another Mill Valley story.)

Richardson took full advantage of his holdings, planting orchards and raising livestock. He also invested heavily in other business enterprises. He is credited with the development of Yerba Buena (later to become San Francisco) as well as the Marin town of Sausalito. Many public streets and landmarks carry his name, including Richardson Bay, on the edge of Mill Valley. Unlike John T. Reed, William Richardson had been a seafaring man all his life. He returned to his maritime roots after settling in the area. He was appointed Yerba Buena's port captain, and he purchased a number of trading and cargo ships that he used for commerce opportunities as far south as San Diego.

Accounts of William Richardson's life indicate that he was a good man, but his entrepreneurial spirit extended beyond realistic boundaries. After suffering a series of calamities, he mortgaged his vast holdings to meet his debts. By 1855, he owed more on the land than it was worth.

Samuel Throckmorton, nicknamed "Five-dollar Throckmorton" for his talent to snap up land from debt-ridden owners, soon owned nearly all of Richardson's *Rancho Saucelito*. Throckmorton transformed the grazing land into dairy ranches, and then leased them to workers arriving from the Portuguese Azores Islands. The rest of the land was the San Francisco businessman's private weekend playground. He put up a fence around the entire property, posting guards at strategic spots, and outlawed trespassers who did not carry a coveted permit to be there. But Throckmorton—like Richardson—eventually found himself in debt. After Throckmorton's death, the savings union holding the mortgage on the land took possession of nearly all of Rancho Saucelito and established the Tamalpais Land & Water Company (TL&W) to manage it. The land was subdivided and auctioned off in 1890. Perhaps as penance for taking the land away from Throckmorton's daughter Susanna, the TL&W named Mill Valley's first street Throckmorton. A number of former Portuguese tenant farmers bought land at the auction. In the end, neither Richardson nor Throckmorton could do what the Portuguese farmers accomplished: have multiple generations of their descendants live on the fertile and pastoral land. (Courtesy of Anne T. Kent California Room, Marin County Free Library.)

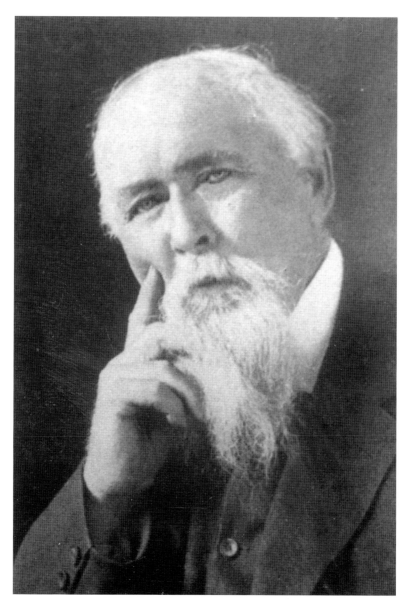

Jacob Gardner, Mill Valley's Caretaker

Jacob Gardner went to work as caretaker on Samuel Throckmorton's ranch in 1868. Five years later, he left to follow his dreams of working his own land and leased a dairy with his brother. He soon married, and babies followed. But when the dairy failed, Jacob faced grim prospects for supporting his new family. A murder changed Gardner's luck. Back on Throckmorton's ranch, Jacob's replacement had been killed for the tenant rent money that he carried. Throckmorton asked Jacob to return, which he did. When Throckmorton died in 1883, his daughter Susanna needed to sell her father's ranch to settle the many debts he left behind. She offered to sell Jacob some of that land. He finally had a home of his own. Building on this first opportunity, his land holdings grew. Jacob served his community in a variety of roles, including as sheriff, county supervisor, and trustee for the newly incorporated Mill Valley. He also brought Mill Valley its first grammar school, eventually known as Summit School. (Courtesy of Anne T. Kent Room, Marin Free Library.)

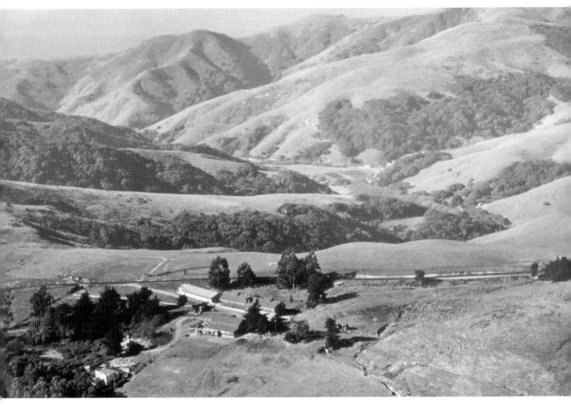

The Dias Family, from Scarcity to the Land of Milk

When Samuel Throckmorton took possession of Rancho Saucelito, he began leasing the land to tenant dairy ranchers. Many of these ranchers had arrived from the Azore Islands, an archipelago governed by Portugal, but 1,000 miles west of the Portuguese mainland.

In the mid-1800s, the Azores were struck by multiple crop failures that devastated the economy and threatened mass starvation. Many of the islands' inhabitants took to the seas and disembarked in California. Because the hardy immigrants arrived with great farming and ranching skills, they are widely credited with turning Marin County into a dairy region.

One of the Mill Valley dairy ranches was the Dias ranch, or Hill Ranch. It is not clear when John Dias first arrived in the area. He may have been one of Samuel Throckmorton's tenants. But in 1898, he bought his first parcel of land from the Tamalpais Land & Water Company. It covered more than 116 acres, and he added to that over the next 19 years. In 1917, Dias was kicked by a bull and died of his injuries. His obituary described him as a wealthy rancher and board member of the Bank of Mill Valley.

The Hill Ranch was passed on to John's son Jim and remained a family-owned operation for many years. This aerial photograph of the ranch was taken around 1961. (Courtesy of Elizabeth McKee.)

Suey Kee, Mill Valley's Other Immigrants

Like much of California during the 19th and early 20th century, Mill Valley relied on the labor of Chinese immigrants. When the Tamalpais Land & Water Company began work on two railroad lines in the 1890s, the company hired Chinese migrant workers to build them. The workers lived in a tent encampment near the corner of Throckmorton and Blithedale Avenues. While living in the encampment, many made extra money taking in laundry, doing handyman chores, and gardening. One industrious worker was Suey Kee, who grew vegetables on rented land and delivered them out of two large baskets suspended from a yoke across his shoulders. He eventually opened a shop.

Since the time that John Reed and William Richardson first arrived on the continent, the area had been very good to European immigrants. But this was not the case for those arriving from the other direction. Chinese workers suffered from discrimination. In fact, one local newspaper specifically vilified Suey Kee for his success. Kee stuck it out, nonetheless, and when he returned to China years later he passed his Mill Valley business on to a relative.

In 1882, Congress had passed the Chinese Exclusion Act, which essentially halted the legal immigration of Chinese into the United States (it remained in place for decades). William Patterson—the first African American student at Mill Valley's Tamalpais High School—wrote in his autobiography that his father had worked on a Chinese clipper ship that smuggled immigrants into the country after the Exclusion Act was passed. His father had joined the crew from his home in the British West Indies. Because Suey Kee's birth date is listed as 1897 and his native home as Canton, it is likely that he arrived in this country illegally, possibly aboard one of those ships. One cannot help but wonder if the two immigrants ever met. (Courtesy of Marin History Museum.)

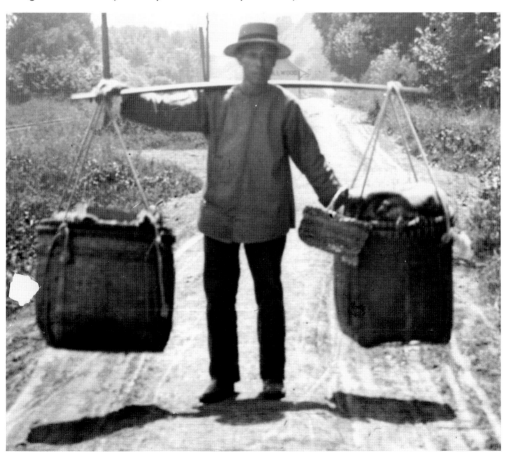

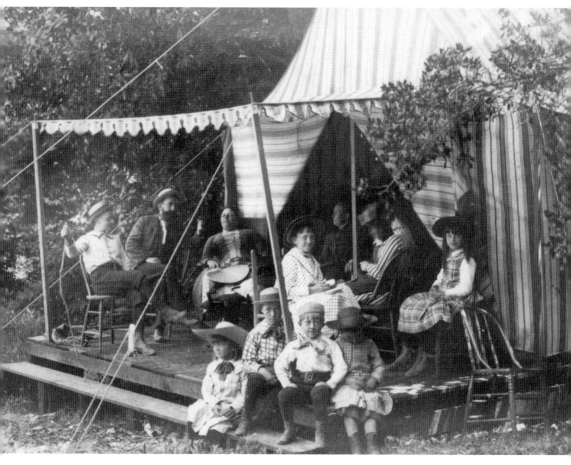

John Cushing, Early Believer in R&R

In the late 19th century, the word "sanitarium" simply meant a place to rest and recuperate. But later, the term was used for tuberculosis hospitals and mental illness institutions. This explains the myths that emerged about what it was that Dr. John Cushing operated in 1873 from his 300-plus acres of land. John Cushing moved his family to the area after purchasing the last remaining swath of land not originally part of John Reed or William Richardson's ranchos. An early practitioner of homeopathy, Cushing wanted to create a retreat for both rest and recuperation. He enlarged the existing house on the property and added simple cottages and tents, calling the early-era spa "Blithedale" after *The Blithedale Romance* by Nathaniel Hawthorne. After Cushing's death, his son Sidney transformed Blithedale into a popular hotel. Though his descendants were loath to be associated with the more distasteful definitions of the word, most accounts confirm that John Cushing did refer to Blithedale as a sanitarium. Modern-day rumors that there was once an insane asylum in Mill Valley were inevitable. Pictured are guests of Blithedale. (Courtesy of Anne T. Kent California Room, Marin County Free Library.)

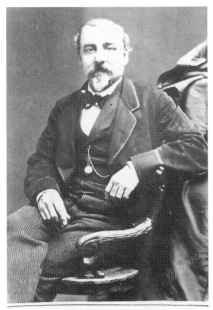

JOSEPH G. EASTLAND.

Joseph Eastland, the Town's First Years

The legend of Joseph Eastland's success begins in 1856 with a suitcase full of playing cards. At 19 years old, Tennessee-born Eastland started clerking in the San Francisco foundry of James Donahue. Soon, Donahue invited the ambitious Eastland to become a stockholder. To raise funds for the investment, Eastland bought a "sight unseen" package of unclaimed goods from a shipping company. The package included a carton of playing cards, a valuable commodity. Eastland invested the profit made from selling the cards into Donahue's neglected gasworks. He eventually became president of San Francisco Gas Company—a precursor of Pacific Gas & Electric.

Joseph Eastland served as a trustee for the San Francisco Savings Union, the bank that held the mortgage on Samuel Throckmorton's land. After Throckmorton's death, his daughter Susanna Throckmorton turned over the majority of the property to the bank to pay off the substantial debt owed on the land. Seeing this as an opportunity, Eastland organized a group of investors and created the Tamalpais Land & Water Company (TL&W). Whether the TL&W bought the property from the bank outright or took control through some other form of transfer is unclear, but by 1889 the TL&W was the listed owner of the former rancho.

To create a throughway for a train into the emerging town, Eastland purchased passage rights from North Pacific Coast Railroad. With his purchase, Eastman took possession of the private railroad car Millwood. Sadly, in 1878, the Millwood broke off from the train that was pulling it and plunged down an embankment, killing Eastland's only daughter, Ethel. Two Mill Valley streets—Millwood and Ethel—owe their names to that story.

Joseph Eastland's private fortune periodically funded the TL&W until the company was able to hold a one-day massive land auction in 1890. Before the auction, Eastland chose a piece of property in Cascade Canyon to build his vacation home, Burlwood. The estate featured paneling, cabinetry, and a grand staircase handcrafted from the burlwood of local redwood trees. Though Eastland entertained there often, it was always considered a summer home.

Joseph Eastland's substantial wealth, southern manners, and pious ways carried great influence in Mill Valley. He implemented many restrictive ordinances and rules during its first years. But despite his authoritarian approach to civic management, there can be no denying his importance in the creation of the town. His rise from foundry clerk to financier and landed gentry testifies to how far a few playing cards can take you. (Left, courtesy of Anne T. Kent California Room, Marin County Free Library; right, author collection..)

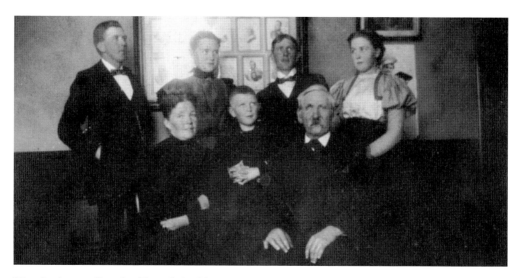

The Anderson Family, Top of the List

The Tamalpais Land & Water Company land auction took place on Saturday, May 31, 1890. The first name on the list of buyers was Anderson. In many ways, Emma and Abraham Anderson, two emigrants from Göteborg, Sweden, were typical of those who bought land on that day.

While Abraham, a carpenter and cabinetmaker, built a small cottage on the property at 102 Lovell Avenue, he, Emma, and their five children slept in a tent on the property. Pictured in 1894 in the image above are, from left to right, (first row) Emma, Carlyle, and Abraham; (second row) Arthur, Lilly, Victor, and Ebba. Abraham later built a larger home at 100 Lovell. (The cottage served as a schoolhouse for one year). Abraham's eldest son, Arthur, who was also a carpenter, may have helped in the construction of the house. In 1925, Arthur restored Mill Valley's old mill (a project that was repeated in 1991). Victor and his wife, Gertrude, bought their own property on 78 Lovell in 1906. Baby daughter Victoria arrived in 1908. In the bottom photograph, she is being escorted by her father in Mill Valley's July Fourth "Beautiful Baby" parade.

When Victoria married Harold Schwartz, the couple moved into the 78 Lovell house. They later relocated to 129 Miller, where they raised their son Fred. All three houses are still standing. (Both, courtesy of Fred Schwartz.)

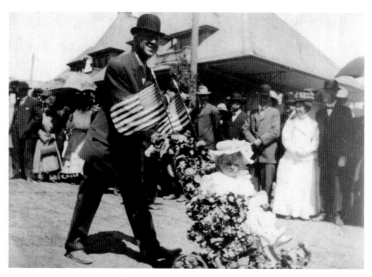

Sidney Cushing, the Third *R*: Recreation

When John Cushing's son Sidney took over Blithedale, he added many amenities, including picking up arriving guests at the train station by private buggy. He also damned the creek to create a "swimming pool" and offered a variety of evening entertainment under twinkling Japanese lanterns. The hotel enjoyed tremendous popularity and many society column inches in San Francisco newspapers. Cushing also subdivided his property, selling lots to an increasing number of summerhouse owners and full-time residents. But of all the projects Sidney undertook to attract people to the area, the most significant was the Mount Tamalpais Scenic Railroad, also known as "Crookedest Railroad in the World." Though the idea of a train up Mount Tamalpais had been a dream of many town fathers, Cushing ultimately stewarded the successful creation of this major tourist attraction. Beginning in 1896, the train twisted up Mount Tamalpais with the engine pushing the open-air passenger cars rather than pulling them, thereby keeping the train smoke from blowing into the faces of the passengers, and allowing them unfettered views. (Courtesy of Bancroft Library, University of California, Berkeley.)

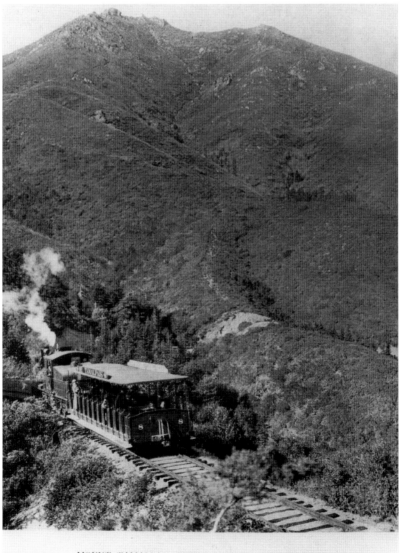

MOUNT TAMALPAIS, MARIN COUNTY, CALIFORNIA

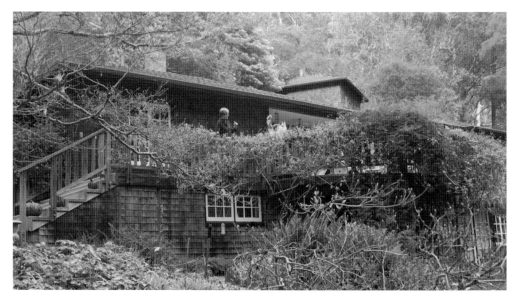

Lillian Ferguson and Fred Stolte, San Francisco Fire Evacuees
In the heart of Mill Valley's Homestead Valley is a public garden. Beginning in a redwood grove, the garden continues through a gated fence to a dell of mop-head and lace-top hydrangeas, lush ferns, and other flora. A footbridge crosses a small stream. This garden was once two gardens, owned by two Mill Valleyans who separately had summerhouses near that spot—Lillian Ferguson and Fred Stolte, both San Francisco journalists. Fred and Lillian became full-time residents when, along with many others, they fled fire-ravaged San Francisco after the 1906 earthquake and fire. In 1974, the property was divided into two parcels, and the Homestead Valley Land Trust purchased the garden. The Land Trust was founded to protect the foothills of the neighborhood from development, creating a permanent green belt around the area. Lillian Ferguson's house remains on private property and looks very much as it did in 1906. (Above, courtesy of Suki Hill; below, author collection.)

**Chuck Oldenberg,
Homestead Historian**
When Fred Stolte built his "bachelor's cabin" near the home of his friend Lillian Ferguson, he could not have imagined that he would one day raise his own family in that spot. But the refugee of the San Francisco earthquake did just that. In 1968, Chuck Oldenberg bought the house. He knew nothing of its history, but that soon changed. Chuck followed Stolte's story and many others, all told to him by longtime residents. He began to track down missing details and record these tales in the *Homestead Headlines*. He also helped in the drive to create the Homestead Valley Trust, which has protected the bucolic setting from urban sprawl. Chuck is a longtime member of the Mill Valley Historical Society board of trustees. (Top, courtesy of Chuck Oldenberg; left, author collection.)

The White Family and the Garden of Allah

When the Tamalpais Land & Water Company (TL&W) took over the property that would become Mill Valley, at least two of the TL&W investors built summer homes on the land. Joseph Eastland's connection to Mill Valley ended with his death in 1894, but Lovell White's connection continues today.

Like Joseph Eastland, Lovell White was a trustee for the San Francisco Savings Union and a member of the TL&W. He took over as the TL&W president when Eastland died. In 1900, Mill Valley was incorporated. Although this reduced the holdings of the TL&W significantly, the company remained influential. Lovell's son Ralston went to work for the TL&W as a surveyor. It was as a surveyor that Ralston first saw the parcel of land in Blithedale Canyon on which he would one day build his dream home.

For Ralston, 1909 was a dramatic year. Lovell White had died the year before, and Ralston had taken his father's place as president of the TL&W. He also met Ruth Boericke at a Blithedale Hotel "summer hop," and the two were married a year later. Ralston's promotion to TL&W president gave him the means to buy his cherished parcel of land, and the design and construction of his dream home began in 1911. The three-story house, with a steel beam frame, was completed in 1917. Ralston named it "the Garden of Allah" after the book by Robert Hichens.

Ralston and Ruth entertained often at their lovely estate, but the stock market crash of 1929 stripped the family of their fortune, and they were forced to rent out the house, fully furnished, and live elsewhere. They were able to move back into their home just before World War II, and Ralston worked diligently to repay the significant debts he had incurred during the Depression. In 1943, just days after paying off the balance of what he owed, Ralston White died.

In 1955, Ruth White donated the Garden of Allah to the Northern California Conference of Congregational Churches. Today, it is the Ralston White Retreat, owned and managed by the Ralston White Retreat Foundation.

Many relations of the Whites have lived in Mill Valley since Lovell and Laura White built a summer home there at the end of the 19th century, and at least one still does. The Garden of Allah was only one of the many ways the White family left a lasting imprint on the town. (Author collection.)

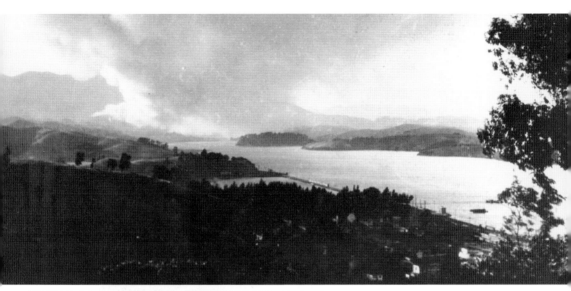

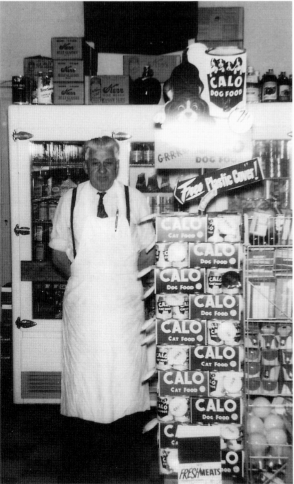

Frank Canepa and the 1929 Fire

On July 3, 1929, Italian immigrant Frank Canepa had just completed the setup of his new produce shop in Mill Valley and was all set to open the next day. But that night, at home in San Francisco, he picked up the newspaper and read that Mill Valley was on fire. He was not sure what he should do, but the next morning he put on his new gray suit and headed to Mill Valley.

The fire had begun on July 2 as a column of smoke rising from behind the Ralston White home, but by 9:00 a.m. on July 4, it could be seen from San Francisco. When Frank Canepa stepped off the train, he found Mill Valley engulfed in smoke. He was quickly recruited to join the other volunteer firefighters. The fire burned for more than four days, but a change in the wind sent it up the mountain, saving the town from complete destruction. An estimated 117 homes were consumed in flames. Surviving his trial by fire, Frank eventually moved to Mill Valley, and his produce shop became the Mill Valley Market, still open today. (Top, courtesy of Marin History Museum; left, courtesy of Bob Canepa.)

25

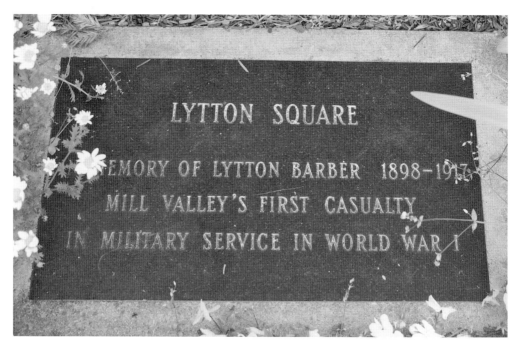

Lytton Barber, Namesake of Lytton Square

In downtown Mill Valley—on Throckmorton Avenue between Peet's Coffee and the Depot Bookstore and Café—a bronze plaque rests by a small grove of redwood trees. The plaque commemorates Lytton Barber—high school football star, member of Troop One (one of California's first Boy Scout troops), and well-loved local boy. Lytton enlisted in the aviation service at the age of 18 during World War I, but he died of spinal meningitis while still in training. That portion of Throckmorton Avenue is referred to as Lytton Square, identified as such in this c. 1969 postcard. (Both, author collection.)

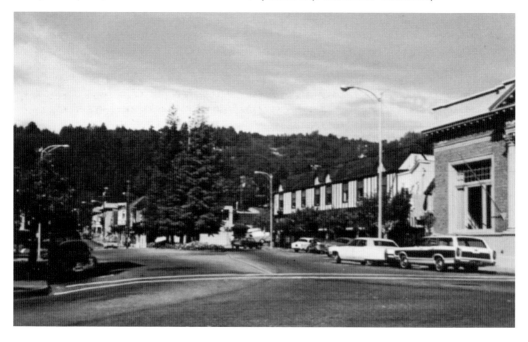

CHAPTER TWO

Bohemia in the Redwoods

The beauty and serenity of nature often allows people to experience life in deeper ways. This can lead to the creation of art, a respect for the environment, or a new perspective on the world. Or all of those things. Mill Valley's natural beauty and geographic "apartness" have made it a beacon for the artist and the dreamer.

Mill Valley's location inside a ring of forests and waterways rouses the artist in many who live there. Paintings dating back to the 1800s capture the bucolic setting and rolling hills of the area, and writers have described Mill Valley's scenery and wildlife in poems and books. Mill Valley seems to inspire creativity. A setting on Mount Tamalpais struck one group of hikers as a dramatic backdrop for epic pageants, so they decided to produce them right on that spot. And one wonders if the serene settings of Tamalpais Valley, Homestead, and Cascade Canyon opened up the space needed for Kathleen Norris, Ray Strong, and Jane Hirshfield to hear their muse. Not all of Mill Valley's artists created with a philosophical or romantic voice, however. Writers like Cyra McFadden, Jack Finney, and John Wasserman wrote from their Mill Valley homes with more irreverent perspectives.

While the beauty of the area encourages sheer enjoyment of the out-of-doors, it also inspires conservationism. At the turn of the century, the railroad had changed the face of the nation. Mill Valley benefitted in many ways from the arrival of the railroad, but with the railroad came an insatiable hunger for timber. Without early conservationists like William Kent and Laura White, the speed of progress would have overrun the speed of reason, and Mill Valley would now be a very different place. Today, winding trails begin in the canyons of Mill Valley and climb to the peak of Mount Tamalpais, taking hikers through fern groves and redwood forests, and past peerless views of the Pacific Ocean and both Richardson and the San Francisco Bays. This is all protected and appreciated by nature lovers of all sorts.

The natural splendor of the area stirs the spirit, as well. Many people came to live in Mill Valley because it wakened within them a search for philosophical answers. For Elsa Gidlow, that meant retreating from the modern world, while creating a salon life of like-minded Bohemians in her "unintentional community;" for George Leonard, it inspired the idea of the Human Potential Movement, impacting thousands of people. Much of the counterculture thinking of mid-20th-century Mill Valleyans drew directly and indirectly from Buddhism. That ancient religion has influenced the culture of Mill Valley—so much, in fact, that meditation and the practice of "mindfulness" have become accepted features in even the most secular parts of town life.

Mount Tamalpais, Mill Valley's Guardian

The muted purples and greens of Mount Tamalpais ("Mount Tam" to locals) are evident throughout the year, and views of the primordial mountain are a powerful selling point for prospective residents. Today, most of Mount Tamalpais is either a state park or other public land entity. But the mountain has a 94941 zip code, giving it a Mill Valley address. To reach it by car, one must drive through Mill Valley. Many Mill Valleyans consider Mount Tamalpais their mountain. And they also consider Mount Tamalpais a "her" instead of an "it."

Any prominent mountain in a region once populated by Native Americans is going to have its legends, and Mount Tamalpais is no exception. The most popular is that of the Sleeping Maiden. Looking at the top of Mount Tamalpais from certain angles, one can see the outline of a person in repose. Some see it more easily than others. People say that the legend of the Sleeping Maiden is an ancient Miwok Indian fable about a princess named Tamalpa. Legend has it that Tamalpa sacrificed her love for an Indian warrior in service to a greater good, and now she lies in eternal slumber, a guardian of the mountain. Her story is told in the play *Tamalpa*, written by Garnet Holme for the Mountain Play, an annual outdoor production on Mount Tamalpais. But Holmes did not get the tale of Tamalpa from any ancient Miwok fable—he made it up in 1921. He admitted this from the beginning, yet the legend of Tamalpa, the Sleeping Maiden, continues to be told to newcomers as a piece of Native American folklore.

The story of Tamalpa may be a 20th-century invention, but the power that Mount Tamalpais has over those who live near it is very real. People are drawn to Mount Tamalpais for its—for her—beauty and serenity. She has been the subject of countless paintings and poems, and the destination for both traditional and alternative spiritual rituals. Legal and emotional battles have been fought to keep the mountain free from development. She is looked upon by many as a guardian of the area and has rewarded those who have defended her with a spectacular natural playground and breathtaking views from many of Mill Valley's steps, lanes, pathways, and trails. (Author collection.)

William Kent, Early Conservationist

William Kent (on the right, standing with John Muir) did not live in Mill Valley, but his impact on it is profound.

The Kent family land holdings began with William's father, Albert Emmitt Kent, a successful Chicago businessman who moved his family to Marin in 1871. Young William grew up living an outdoor life at the foot of Mount Tamalpais. After college and some years living in Chicago, William moved his family to Marin, as his father had done, and began adding to the Kent family land holdings, including many acres on and around Mount Tamalpais. In 1910, the progressive Republican was elected to the US House of Representatives, serving three terms.

Kent was a lifelong conservationist. In 1903—possibly inspired by Mill Valley matriarch Laura White, an early defender of the California redwood tree—Kent bought a parcel of land that had on it a large forest of redwood trees. He bought the land to save it from logging interests, but in 1907, a portion of the land fell into danger of being condemned and developed into a dam. Kent considered the move a pretext to log the forest. He saved the canyon by convincing Pres. Theodore Roosevelt to invoke the Act for the Preservation of American Antiquities. The Antiquities Act gave the president the power to declare as a national monument any land he deemed valuable under certain parameters. Kent requested that the newly created monument be named for John Muir. Roosevelt wanted to name it Kent Monument, but Kent objected. In a letter to President Roosevelt, he suggested that immortality was not something "purchasable." He went on to say that he had raised his five sons to value the rights of the "other fellow." "If these boys cannot keep the name alive," he wrote, "I am willing it should be forgotten."

William Kent's children did keep his name alive, primarily through the donation of much of his property to the public domain. Eventually, Muir Woods became part of an uninterrupted stretch of publicly owned land. It begins in Mill Valley and goes all the way to the Pacific Ocean. (Courtesy of Anne T. Kent California Room, Marin County Free Library.)

Alice Eastwood, Trails and Travails

Alice Eastwood, a curator of botany at the California Academy of Sciences during the turn of the 20th century, often spent weekends hiking the trails of Mount Tamalpais. Her studies of the region's native plants made a significant contribution to botanical science. She helped create the first hiking map of Mount Tamalpais. Her name is in many places on the mountain, including a campsite dedicated to her by the Tamalpais Conservation Club on her 90th birthday.

As botany curator for the academy, Alice had responsibility for rare and irreplaceable botanical specimens. On an April morning in 1906, she felt the earth move beneath the building where she rented a garret apartment. She wasted no time making her way to the academy, where she entered the earthquake-damaged building and began evacuating the specimens. She made numerous trips up six flights of stairs, lowering sacks full of plants and equipment out the window. She saved much of the valuable collection, but as the fire that erupted after the earthquake grew closer to the academy, she had to abandon the remaining samples and volumes of important research notes to the flames.

For a number of years after the Great Fire, Alice lived a somewhat nomadic life, but continued her hikes on Mount Tamalpais when she could. These visits acquainted her with the people of Mill Valley, including Ralston White. In 1909, White agreed to sell Alice a piece of property on Summit Avenue. She began building a house there in 1912, and soon had created a garden that functioned as a botanical laboratory. She filled it with plants collected from her travels. Then, in July 1929, while out of town, Alice got word that—once again—her rare collection of flora had been lost to flames. Her home and garden had been destroyed in Mill Valley's now historic fire. Alice could not even bring herself to see the remains of her home, and she had her brother-in-law arrange the sale of the land.

Alice did not visit the spot again for seven years. When she did, she discovered that a number of the specimens destroyed in the fire had come back and were thriving. Alice had written some years earlier that many plants rely on fire to create an environment for new growth. Alice found solace in the notion that her former garden-laboratory provided evidence of that resiliency. Alice Eastwood was resilient, as well, and lived to be 95. She is pictured here with John Thomas Howell. (Courtesy of Anne T. Kent California Room, Marin County Free Library.)

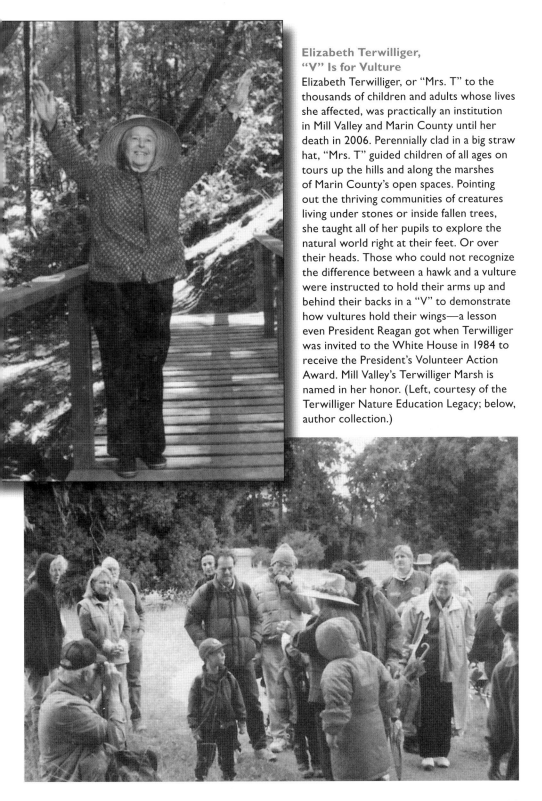

Elizabeth Terwilliger, "V" Is for Vulture

Elizabeth Terwilliger, or "Mrs. T" to the thousands of children and adults whose lives she affected, was practically an institution in Mill Valley and Marin County until her death in 2006. Perennially clad in a big straw hat, "Mrs. T" guided children of all ages on tours up the hills and along the marshes of Marin County's open spaces. Pointing out the thriving communities of creatures living under stones or inside fallen trees, she taught all of her pupils to explore the natural world right at their feet. Or over their heads. Those who could not recognize the difference between a hawk and a vulture were instructed to hold their arms up and behind their backs in a "V" to demonstrate how vultures hold their wings—a lesson even President Reagan got when Terwilliger was invited to the White House in 1984 to receive the President's Volunteer Action Award. Mill Valley's Terwilliger Marsh is named in her honor. (Left, courtesy of the Terwilliger Nature Education Legacy; below, author collection.)

Tom Killion, the Art of Mount Tamalpais

Tom Killion grew up in Mill Valley in the 1950s and 1960s. The natural beauty of his home at the base of Mount Tamalpais inspired him to become an artist at an early age. When he was still a teenager, he sold his first pen-and-ink drawing at Mill Valley's annual art festival. Tom's father regretted the sale and tried, unsuccessfully, to buy the drawing back. Tom subsequently made his father a linocut print of the image—a quail—and sold additional copies of the print at the fair the following year. Eventually, Tom mastered the Japanese technique of ukiyo-e wood block printing, and today his prints are exhibited around the world.

Tom has partnered twice to create books with Zen Buddhist and naturalist Gary Snyder. (Snyder—sometimes called "the Thoreau of the Beat Generation"—is the model for the character of Japhy Ryder in Jack's Kerouac's novel *The Dharma Bums*.) Their latest book, *Tamalpais Walking,* is a rich collection of art, poetry, history, and folklore about Mill Valley's most cherished symbol, Mount Tamalpais. (Both, courtesy of Tom Killion.)

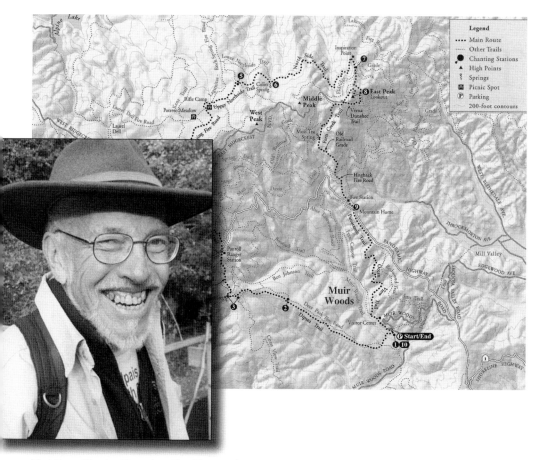

Matthew Davis, Opening the Mountain

Spiritual practices associated with the Far East have been a part of Mill Valley's heritage even before Jack Kerouac wrote *The Dharma Bums* in 1957 (while living in Orlando, Florida). The book mirrors Kerouac's real-life exploration of Buddhism and his friendship with Gary Snyder, with whom he shared a cabin in Homestead Valley before Snyder left for Japan in 1956.

Snyder's travels in Asia brought him to India as well as Japan, and he returned to the United States newly educated on a particular spiritual practice. The practice, known in India as *pradakshina*, was a ceremonial walk around a sacred object. Japanese and Chinese Buddhists conducted a similar walking meditation, which they called "opening the mountain." Upon his return to the United States, Gary Snyder and fellow dharma bums Allen Ginsberg and Philip Whalen conducted their first ceremonial walk around Mount Tamalpais. Two years later, in 1967, the practice of "opening the mountain" took place again. This time all were invited. It quickly became an annual event.

In 1974, Mill Valley resident Matthew Davis (no relation to the early-20th-century hiker for whom a Mount Tamalpais trail is named), began leading the ritual walk. Though some of its characteristics may change, the essence of the ritual remains the same—a circumambulation of Mount Tamalpais, with stops for a series of chanted meditations. It begins at 50 feet above sea level and reaches the mountain's highest peak at 2,571 feet before descending to complete the circle of roughly 15 miles, all done in one day. Today, "Opening the Mountain" takes place four times a year on the Sunday before both solstices and equinoxes. Matthew Davis is always at the starting point to greet the hikers, regardless of the weather. He has led the walk more than 140 times. The book *Opening the Mountain* by Matthew Davis and Michael Farrell Scott tells a more complete story of the ritual and its origins. (Left, courtesy of Bob Flasher; top, author collection.)

Elsa Gidlow, Druid Heights

In 1953, bohemian intellectual, anarchist, and self-described lesbian-poet Elsa Gidlow dreamed of living in a "small, extended-family community with compatible interests." But her dream seemed beyond her reach until she attended a picnic. "We had been seated with our lunch . . . when a man wearing nothing but a loincloth . . . asked [to] join us," Elsa wrote in her memoir, *Elsa I Come With My Songs*. The man was Roger Somers, a frenetic but charismatic artist who designed buildings influenced by the work of Frank Lloyd Wright. Roger's dream was to own land on which he could build his designs. Roger told Elsa about a five-acre property for sale in an isolated and densely wooded area of unincorporated Mill Valley. The price was $4,000. Elsa visited the property and found a secluded farm at the end of a four-mile, one-lane dirt road—miles from so much as a gas station. For her, it was perfect. Elsa secured the $4,000 and purchased the property. Somers eventually became an owner, as well. Elsa named it Druid Heights. In the following years, Roger's whimsical structures and auxiliary buildings popped up on the property like magical mushrooms. For its first 16 years, Druid Heights functioned as a social salon for the creative-minded. Beat Generation notables such as Allen Ginsberg and Jack Kerouac are said to have visited. It was also the full-time home to 12 people. Others lived there periodically, including Elsa's good friend and Eastern-influenced freethinker Alan Watts. Watts eventually lived in a building designed by Somers and built by Ed Stiles, the third owner of the Druid Heights property. The house had originally been built for Elsa's sister Thea. Watts named it Mandala House, and that is where he died in 1973.

Life may have been unorthodox at Druid Heights, but through the 1960s it remained relatively quiet. That changed in the early 1970s, possibly due to an article Elsa wrote about the enclave for the *San Francisco Examiner*. During that time, "intentional communities," or communes, were becoming popular. But that was not what Druid Heights was, Elsa wrote: "[It is] an unintentional community . . . innocent of ideology . . . organic, growing out of the inner needs of the participants." That seemed to appeal to many, because, although Elsa did not reveal the location of Druid Heights, people found it. Soon, the previously intimate community of artisans and intellectuals became the home to a much larger—sometimes eccentric, sometimes volatile—population. (Courtesy of Marilyn Stiles.)

Ed and Marilyn Stiles, Druid Heights Today

Ed Stiles arrived in Marin County with his wife, Marilyn, in 1965. His dream was to set up a workshop to make custom furniture. He looked up Roger Somers, whom he had met on a previous visit to Marin, hoping Roger could help him find a place for his shop. As it turned out, there was an empty space in one of the buildings—perfect for Ed's needs—right at Druid Heights. Ed and Marilyn moved in. Not long after that, they bought into a one-third ownership of the five-acre property.

Ed became a sought-after furniture designer and woodworking artisan. His reputation was in part built on his early work for four different churches, to which he provided some of his gracefully curved furniture, made from quality hardwoods. Later, he built a number of pieces for musician Graham Nash, including an integrated collection of furnishings for Nash's in-home recording studio. And though Rogers Somers had designed Mandala House, where Alan Watts lived his last years, it was Ed who built it.

Ed recalls loving the impromptu music and other spontaneous social gatherings so common during Druid Heights's early years. But as the population of the community increased in the early 1970s, so did the culture of drug use. This threatened to influence Ed and Marilyn's two young sons. They had no desire to leave their home, and so Ed, Marilyn, and their boys lived slightly apart from the rest of the fluid community from then on.

By the mid-1970s, all of the land around Druid Heights had been accumulated by state and national parks. Faced with the threat of losing their homes under eminent domain laws, the Stiles, Elsa, and Roger negotiated a life estate, allowing them to remain on the land as long as it was family-owned. Ed and Marilyn still live there. Ed now has a spacious and light-filled workshop, which he designed and constructed himself from the ground up. Marilyn is a talented ceramic artist. They are entirely surrounded by public parkland, and have outlived the two Druid Heights founders and an entire social movement. "We're the oldest critters in the forest now," Marilyn says with a soft laugh. (Author collection.)

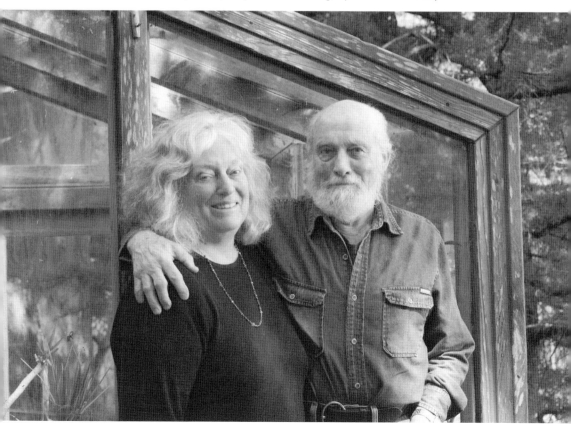

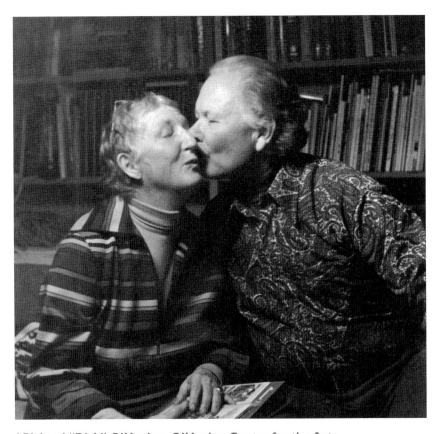

Ann and Richard "Dick" O'Hanlon, O'Hanlon Center for the Arts

Mill Valley has a rich history of informal art colonies. These colonies often sprouted from the remaining roots of faded eras. In the 1930s, many San Franciscans whose financial luck had changed after the Great Depression sold their Mill Valley summer cottages inexpensively to painters and writers who happily made full-time homes of the simple cabins. These cabins were often clustered together, as Camp Tamalpais in Homestead Valley was, and so creative communities naturally evolved. In the 1940s, when dairy ranchers began to sell off their land, the former grazing pastures and empty barns were well suited to the aesthetic tastes and modest needs of young artists. Ann and Dick O'Hanlon were two such artists.

In 1942, Ann, a painter, and Dick, a sculptor, purchased acres of ranch land from Portuguese dairy farmer Antonio Freitas. The Cascade Canyon property extended from Throckmorton to Lovell Avenue. It included a small barn, which Ann and Dick rebuilt into an art studio. A significant group of artists collected around this creative nucleus. All were friends and shared similar ideals. Many of them set up their own live/work spaces in the same neighborhood. Over the years, more buildings were added to the O'Hanlon property. Both Ann and Dick made considerable artistic contributions to the town throughout their lives. In 1941, Dick conducted demonstrations in the courtyard of El Paseo, another hub of artistic life in the 1940s. A Richard O'Hanlon sculpture is installed outside the Mill Valley library. Ann was a painter and a teacher. She founded the art department at Dominican College, but left in the mid-1960s to teach art in a way that she felt to be more intuitive and inspiring. At first she taught informally, then in 1969, she and Dick created Sight and Insight on their land, a nonprofit art organization that evolved to become O'Hanlon Center for the Arts.

Today, the O'Hanlon Center includes programs and classes in an array of creative disciplines, a full exhibition gallery, and studio space. It remains a thriving and intrinsic part of Mill Valley's artistic community. (Photograph by Genevieve Williams, courtesy of O'Hanlon Center for the Arts.)

Ray Strong, a Bold View of Mill Valley

One member of the O'Hanlon community was Ray Strong, who lived in Mill Valley for many years. He is most famous for his sweeping landscapes. He valued the area's rich, late afternoon light for its ability to reveal the region's bold topography. He would sometimes combine different perspectives for dramatic effect. In the painting shown here (commissioned by Mill Valley's Outdoor Art Club and still hanging there today), Ray merged a view of Mount Tamalpais from the west side of Mill Valley's Bothin Marsh with a second view across a rocky, open field on the marsh's eastern side.

People admired Ray for his open-heartedness as much as his art. Judith Strong Albert, Ray's niece, recalls appreciating his talent even as a young girl. "We called him 'Painter Man' because he was so good at capturing the beauty of nature and life in his paintings," says Judith, who is quick to add, "He was the most spirited, generous, outgoing human being that God ever created." Ray died in 2006 at 101 years old. (Above, courtesy of Abby Wasserman; below, author collection.)

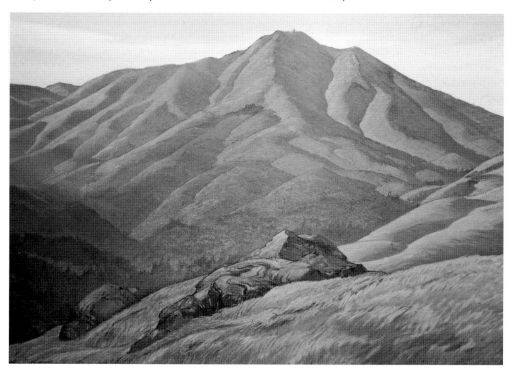

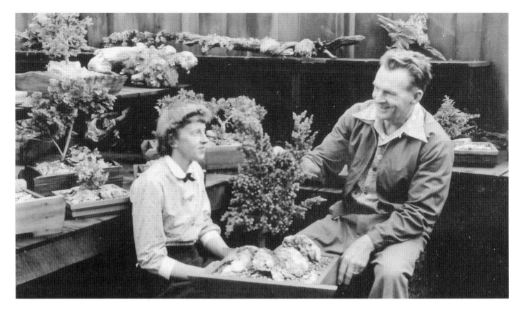

Samuel "Sam'l" and Sylvia Newsom, the Art of the Garden

Samuel, or "Sam'l," as his friends called him, grew up spending summers in his parents' Mill Valley summer cottage and moved into the cottage as an adult. In the 1930s, he went to Japan and studied the art of Japanese garden design. His affinity for the Japanese people inspired Samuel to store and protect 42 truckloads of valuables belonging to the Hagiwara family at his cottage when the Hagiwaras were sent to an internment camp during World War II. The Hagiwaras were the caretakers for Golden Gate Park's Japanese Tea Garden, and Sam'l would later play a major role in the restoration of that garden. In 1947, Sam'l—like his friends the O'Hanlons—bought some property and an old barn in Cascade Canyon, which he converted into his home, an art studio, and a showcase for his landscape designs. Sam'l was also a painter, and for nine years in the 1950s, a group of local artists met every Friday night in the "barn" to paint and draw together. Their models ranged from friends and family to well-known names, including actress Carol Channing, whose aunt and uncle lived in Mill Valley at the time. Sam'l married his wife, Sylvia, in 1949. Sylvia provided the photographs for many of Samuel's gardening books. The two owned a Bonsai plant and Japanese-influenced gift shop in Mill Valley. It may have been the town's first introduction to the Zen aesthetic that Mill Valleyans now embrace with enthusiasm. Today, the Newsoms' daughter lives in the "barn" and maintains her father's peaceful garden. (Both, courtesy of Sylvia "Chipps" Newsom.)

Valborg "Mama" Gravander, Old World Artisan

In the 1920s, Swedish weaver Valborg "Mama" Gravander hosted a regular Friday night smorgasbord and folk dancing party in her San Francisco home. Dick O'Hanlon and Sam'l Newsom often attended. When Mama and her husband, Alex, took up full-time residence in their Mill Valley summer cottage in 1945, they were already part of the O'Hanlons' group of friends. Every December 13, Mama hosted her popular Swedish "Santa Lucia" gathering. The Saturday before, children would help her bake the traditional Swedish *peppakakor* (ginger cookies) for the Lucia festivities. She took great pleasure in seeing the children in the neighborhood grow up around her cookie-baking table. (Courtesy of Suki Hill.)

Steve Coleman, Mill Valley's Set Designer

Not too many towns can boast that they have their own set designer, but Mill Valley can. Native Mill Valley artist Steve Coleman has not only designed many of the sets for the Marin Theatre Company, Tam High's Conservatory Theatre Company, and 142 Throckmorton Theatre, he has also generously donated his talent for other nonprofit events. For example, the beautiful hand-carved screens that frame the Milley Award recipients on stage each year are Steve Coleman creations. (Courtesy of Suki Hill.)

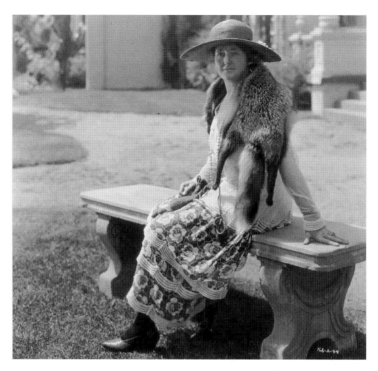

Kathleen Norris, the Author from Treehaven

In 1890, a San Francisco bank employee named James Alden Thompson and his wife, Josephine, bought two Mill Valley lots and set about building a house on the property. It was a shingled cottage, set within a redwood grove and built into a hillside. Josephine named the house "Treehaven." When construction was complete, the couple and their children took up full-time residence in Mill Valley. One of those children, Kathleen, would grow up to become a successful novelist.

Kathleen was 11 years old when they moved to the tiny town. She began classes in a temporary schoolhouse with only a few other children. Her knowledge must have surpassed that of other students, because the following year she became a teacher for the youngest pupils, thus ending her own primary school instruction.

Though her school days ended early, Kathleen was in no way deprived of an education. Her father was a voracious reader, a skill he fostered in his children. Her parents entertained a steady stream of visitors, including authors and musicians, and Kathleen was encouraged to join in their discussions. Kathleen's days were spent reading on nearby hilltops. In the evenings, her home was filled with stimulating fireside conversations and the sound of music. And at bedtime, she invented stories to tell her siblings. Kathleen, a great Charles Dickens fan, lived the kind of rich family life celebrated in Dickens's novels.

Kathleen's tranquil family life ended in 1897. Both her parents died within three weeks of each other. The Thompson family could not afford to remain in Treehaven, so they moved to a small flat in San Francisco. They rented out the Mill Valley house, and Kathleen took a series of jobs to help support her aunt and siblings. But on April 18, 1906, while the family was staying at Treehaven and preparing it for new tenants, the San Francisco earthquake and fire destroyed their San Francisco home. They remained in Mill Valley, and some family members stayed permanently.

Kathleen had always enjoyed making up stories, but she never imagined she could make a living as a writer. However, when she lost her job after the earthquake, Kathleen went to work for the *San Francisco Call* newspaper as a reporter. This led to more writing opportunities. By the time she married her husband, Charles Norris, also a writer, her writing was being published regularly.

When she died in 1966, Kathleen Norris had published at least 80 novels. She was the highest-paid female writer of her time. (Courtesy of Bancroft Library, UC Berkeley.)

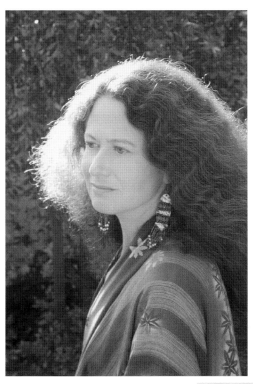

Jane Hirshfield,
Resident Poet Laureate
If Mill Valley had its own poet laureate, Jane Hirshfield would be one of many worthy contenders. In 2012, the award-winning poet and essayist was elected chancellor of the Academy of American Poets. Like many artists and writers who live in Mill Valley, Jane finds the natural beauty and serenity of her hillside neighborhood a welcome respite from a hectic schedule of international travel, teaching, and lecturing. (Photograph by Nick Rosza, courtesy of Jane Hirshfield.)

John Wasserman, "Wassy"
Columnist and entertainment critic John Wasserman grew up in Mill Valley and lived there during the years he wrote for the *San Francisco Chronicle*. Sometimes writing in the voice of alter ego "Wassy," John's wry and sometimes-acerbic columns placed him squarely among San Francisco's upper echelon of newspapermen. At 4:00 a.m. on February 25, 1979—hours before a total solar eclipse—John died in a fiery car accident. Frances Moffats, *San Francisco Chronicle* society editor, would later speak of the eclipse as a metaphor for how she felt upon hearing of John's death: "It's as though the light had gone out in San Francisco." (Courtesy of Abby Wasserman.)

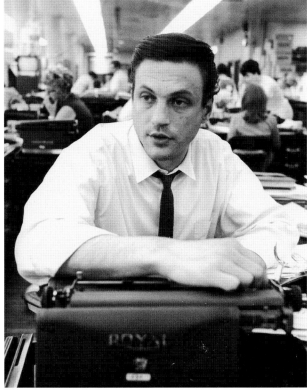

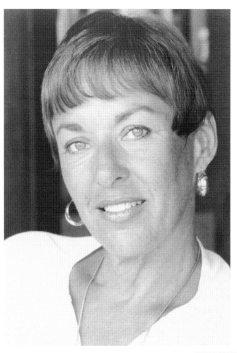

Cyra McFadden, *The Serial*
When the *Pacific Sun* newspaper approached Mill Valley resident Cyra McFadden in 1975 and asked her to write a satire of Marin County, she could not have known what lay ahead. Her cast of brie cheese–eating characters, who were into Transcendental Meditation and "body personality awareness," embodied the most stereotypical beliefs held about Mill Valley and Marin County in the 1970s. Cyra's weekly installments became a must-read. But not everyone was happy. "I started getting anonymous phone calls [and] love-it-or-leave-it letters," Cyra said in an interview at the time.

When *The Serial* came out as a book in 1977, litigation threats began. But Cyra pointed out that potential plaintiffs would have to say things like "I'm the guy in the book who gets deviled egg in his chest hair." The lawsuit threats went away.

Cyra went on to great success as a writer, and she happily remains a Marin County resident. (Left, courtesy of Milley Awards; below, book illustration by Tom Cervenak, author collection.)

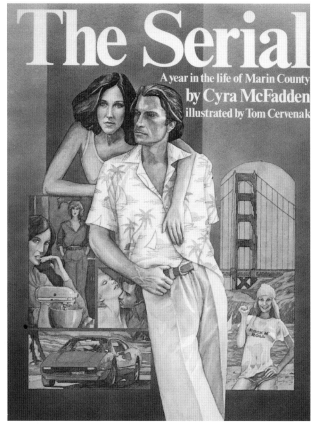

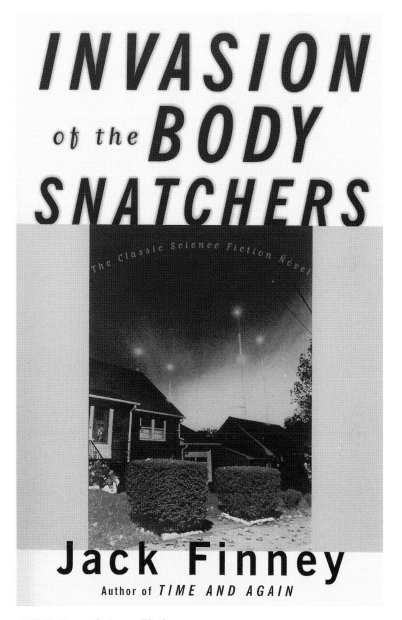

Jack Finney, Mill Valley as Science Fiction
The expression "pod people" is sometimes used to define robotic or superficial behavior. The term can be traced to science fiction author Jack Finney. Finney's *Invasion of the Body Snatchers*, published in 1955 (first published as *The Body Snatchers* in 1954), tells the story of an alien invasion that replaces a small town's residents with polite but emotionless beings that are grown in pods. Finney's choice to place the story in his hometown of Mill Valley makes the book particularly creepy to read for those who live there. Local landmarks such as Blithedale Avenue, unincorporated Strawberry, and the Sequoia Theater are identified by name. Over the years, reviewers have seen *Invasion of the Body Snatchers* as an allegory on everything from industrialization to communism. But some Mill Valleyans feel that when the book's narrator describes the mutation of the town he grew up in, he is voicing Finney's own concerns about the changing character of Mill Valley. (Author collection.)

Suki Hill, Chronicler of the Town

Suki Hill has been recording Mill Valley life through the lens of her camera since 1967. Though Suki's photographs include iconic rock stars of the 1970s such as Jimi Hendrix, Janis Joplin, and The Who, she is most proud of her many years of photographing the lives of ordinary individuals in her beloved hometown. Suki's photographs have documented Mill Valley's celebrations, spontaneous gatherings, and historic events; since the 1960s, they have also captured many of the town's most memorable individuals. For nearly 10 years, the Mill Valley library kept Suki's archival work, *A Photographer's Intimate View of Mill Valley,* on display in its gallery. Her most recent collection showcases Mill Valley at work, with images of the many people who make their living in the shops, parks, and restaurants of the town. If Suki had not been there with her camera, there may not be any photographic record of some of Mill Valley's most legendary locals. (Courtesy of Suki Hill.)

**Skip Sandberg,
Act Two: Photography**
A Mill Valley resident since 1977, Skip Sandberg traded in his banker's suit for a camera in 2002, launching a second career as a photographer. Since then, he has exhibited work in many Marin County venues, earning him a Marin Photographer of the Year award in 2008. In 2010, Sandberg published an outstanding book of photographs and history, chronicling Mill Valley's steps, lanes, and paths system. (Above, courtesy of Skip Sandberg; left, photograph by Anne Fricker, courtesy of Skip Sandberg.)

Sali Lieberman, Lifelong Thespian

Sali Lieberman arrived in Mill Valley a few years after escaping from Nazi Germany, and he brought a great deal of theater experience with him. In the early 1930s, he worked with Bertolt Brecht as a member of Zurich's repertory company, and he continued in theater and films after immigrating to the United States. As evidenced in the photograph of Sali performing at a Mill Valley variety show, Sali loved any form of theater, whether professional or amateur. In 1966, he gathered 35 like-minded theater buffs into the living room of Mayor Albert White and proposed the creation of a performing arts organization. By 1968, Sali was managing director of the Mill Valley Center for the Performing Arts (MVCPA), a fully incorporated nonprofit. MVCPA produced a variety of live performances as well as viewings of new, independent films—most shows were held in the small Mill Valley golf clubhouse. Sali remained managing director until his death in 1982. Two years later, the name was changed to the Marin Theatre Company. (Left, photograph by Bob Hax, courtesy of Milley Awards; below, courtesy of Jacki Fromer.)

Ivan Poutiatine, Living Life on a Learning Curve

Ivan Poutiatine arrived in Mill Valley in 1965. The Yale-trained architect loved the way that the San Francisco Bay Area embraced new ideas, as opposed to the more conservative inclinations of the East Coast. He had not lived in Mill Valley very long before he found himself appointed to Mill Valley's Architectural Design Review Committee, and then the planning commission. Eventually, he was elected to two terms on the city council. At many times, he insisted that he did not have the right experience for the job, but others disagreed. "I found the learning curve to be steep," he said of those years, "at least at the beginning." But the biggest learning curve lay ahead of him. If asked, Ivan will say that one of the most significant moments in his years of community service was the morning he woke up and read in the paper that his good friend Sali Lieberman had put him on the board of directors for the Mill Valley Center for the Performing Arts (MVCPA). "The reason God put curves in the road was so that we couldn't see too far ahead, for fear we'd never leave home," Ivan would say years later.

When Ivan joined the board, the MVCPA was still staging productions in borrowed spaces. But in 1980, Ivan, along with friend and fellow architect Dick Jessup, championed efforts to build the company a theater. In 1985—one year after MCCPA changed its name to Marin Theatre Company—the doors opened on what would eventually become a two-theater building. The Marin Theatre Company (MTC) is now an award-winning enterprise. Ivan has been on the MTC board—heading up many key projects— for more than 30 years. He has seen it develop into an organization that not only offers new as well as classic plays, but also provides theater education, youth programs and classes, community outreach, and new playwright awards and commissions. Ivan says that it has been fascinating to be involved with such a serious organization through its largest growth stage. And that growth owes no small debt to Ivan's efforts. "What keeps me going," said Ivan in 2013 as he looked back at his role in MTC's growth, "is knowing I had something to do with this." (Inset, courtesy of Milley Awards; below, author collection.)

"Dad" O'Rourke and Garnet Holme, Scenes on the Mountain Top

During a weekend hike on Mount Tamalpais in 1912, Richard Festus "Dad" O'Rourke (above), Garnet Holme (below), and a small group of friends came upon a spot that looked very much like an outdoor theater. In a letter to Holme, written some years later, fellow hiker Augustin (Gus) C. Keane recalled the moment when Holme "burst out with the wild idea" to produce a play in the natural amphitheater. Amazingly, the band of hikers did produce a play on the mountain the very next year. Fellow nature lover William Kent owned the land, but when the group formed the Mountain Play Association in 1914, Kent deeded the parcel to the association with the caveat that they continue to produce plays there for the next 25 years. The plays did continue and still do to this day. Garnet Holme directed the plays until 1927, and Dad O'Rourke became the first superintendent of Muir Woods National Monument. In the 1930s, the theater became part of Mount Tamalpais State Park, and the Civilian Conservation Corps, A WPA project, installed stone seating. (Both, courtesy of Anne T. Kent California Room, Marin County Free Library.)

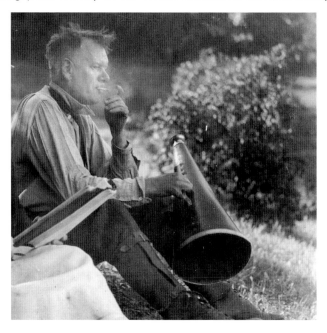

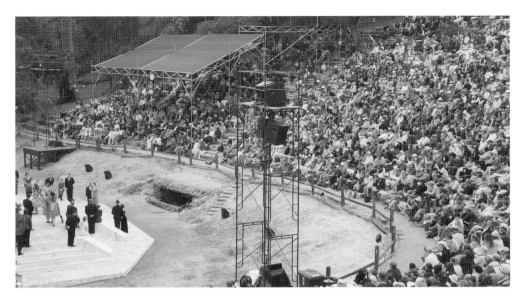

Sara Pearson, Marilyn Smith, and Jim Dunn, Modern Mountain Play
The Mountain Play Association went from being an amateur organization—depending exclusively on volunteers—to a professional theater association in the last third of the 20th century. In the late 1960s, the histrionic themes of the earlier plays held no appeal to audiences emerging from the "Summer of Love," and attendance dropped off dramatically. In 1977, the Mountain Play Association board brought in veteran theater producer Marilyn Smith to breathe life back into the shows. She took the job on the condition that she be allowed to produce Broadway-style musicals. Audiences responded to the change with enthusiasm. In 1981, Jim Dunn took the job of director, and the Mountain Play enjoyed a second golden era. Marilyn retired in 1999, and Jim Dunn retired in 2012. Today, Sara Pearson sits at the helm of the organization and, for now, the play's directorship is an annual guest-director format. (Above, author collection; below, photograph by Gary Ferber, courtesy of Mountain Play Association.)

George Leonard, Human Potential

Author, musician, composer, aikido expert, and human potential leader George Leonard lived in Mill Valley for more than 40 years. His journalism career began at *Look* magazine, and he went on to write 12 books and countless essays on subjects ranging from education to civil rights. With his friend Michael Murphy, George founded the Integral Transformative Practice, International. He was very active in the Human Potential Movement that made Mill Valley and its environs famous (and infamous, occasionally) during the self-exploratory 1960s and 1970s. He is actually credited with coining the phrase "Human Potential Movement." George was also a gifted musician. He composed the music for the first musical performed by the Mountain Play in 1977, *Clothes*.

George held a fifth-degree black belt in the martial art of Aikido. In 1976, he cofounded Aikido of Tampalpais, which stood for many years in downtown Mill Valley.

George Leonard lived a renaissance life—discovering new quests and new parts of himself many times. His death in 2010 struck his many Mill Valley friends deeply. "My favorite word in the English language," George once wrote, "is generosity." (Photograph by Gene Cohn, courtesy of Milley Awards.)

CHAPTER THREE
Visionaries and Quiet Champions

It is said that a good leader inspires people to believe in him or her, but a great leader inspires people to believe in themselves. Mill Valley has had many great leaders. They have helped people see what could be accomplished, even in the face of ridiculous odds. These leaders have also helped people to see that working to achieve thoughtful, long-term solutions is in everyone's best interest. People like Peter Behr and Dick Jessup stand out as examples of the best kind of leadership. And there are many others.

Great leaders are often visionaries, but not all visionaries choose leadership roles. Michael O'Shaughnessy, who designed the layout of the early town of Mill Valley, envisioned a town quite original in its incorporation of the area's natural landscape, where even the most modest parcel of land allowed for exposure to fresh air and pleasant views. O'Shaughnessy's design was completed in a relatively short amount of time, leaving others to build on his groundwork. Other visionaries saw a growing problem in Mill Valley that no once else saw—people like Vera Schultz and Elizabeth Moody—and they set about finding solutions and helping others see the need as they did. It took the perspective of people like Phyllis Faber and Huey Johnson to understand the relationship of Marin's seashores, marshes, and pastoral open spaces to the quality of life inside Mill Valley's borders.

And in every thriving community there are quiet champions. These people fill the needs of the most vulnerable, and advocate behind the scenes for what is right, or what is needed, without drawing any attention whatsoever to themselves. Without people like Karen Schurig, Dennis Fisco, and Anne Layzer, many people in the community would not have the support or information that they depend on. These quiet champions are inevitably surprised when they receive public recognition for their work, but they are the absolute bedrock of a strong community, and their praises must be sung.

Leaders, visionaries, and quiet champions. Such people make up an important part of Mill Valley's story. Only some of those stories can be told here.

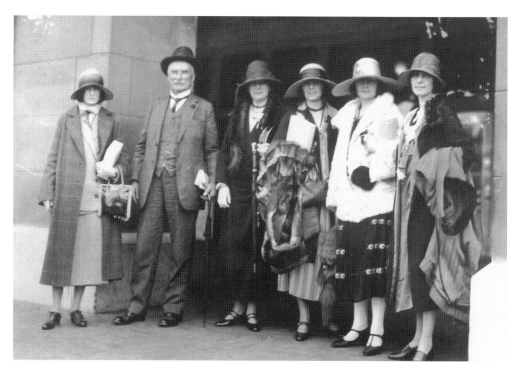

Michael Maurice O'Shaughnessy, "The Chief"

Anyone visiting Mill Valley today would not describe it as a "planned community." The term evokes images of identical tract houses on tight, geometric grids. But a planned community, it is. Fortunately, the planner was Michael M. O'Shaughnessy.

Irishman Michael Maurice O'Shaughnessy (pictured here with his wife and four of his five adult children) arrived in San Francisco in 1885 with an engineering degree from the Royal University of Ireland in Dublin. The talented engineer founded his own consulting company in 1888, providing private civil engineering services to many towns. In 1889, the Tamalpais Land & Water Company hired him to design the town they would create after their land auction the following year. In 1893, he built a summer cottage on Summit Avenue. Over time, the house grew to three stories, becoming his family's full-time residence until he became the city engineer for San Francisco in 1912 and moved to San Francisco's Pacific Heights neighborhood. O'Shaughnessy worked as chief engineer on so many public projects that he earned the nickname "the Chief" from San Francisco mayor James Rolf. O'Shaughnessy's most-recognized accomplishment from those years is the Hetch Hetchy Reservoir, the primary source of San Francisco's water supply. The Hetch Hetchy's O'Shaughnessy Dam is named after him.

But back in 1889, O'Shaughnessy was camping out in a tent and knee high in rainwater, surveying the Mill Valley land and strategizing its layout. Despite the unpleasant working conditions, O'Shaughnessy saw the natural beauty of the area and designed the town to maximize those features. Streets skirted around redwood groves and rambled near streams, and he incorporated a pathway system for pedestrian passage that curved and climbed between the streets and up the hillsides. Once the pathway system was completed, townsfolk would come down the winding lanes at night, lanterns in hand, for community gatherings. People who remembered those early days said the glowing lanterns weaving through the darkness looked like a parade of fireflies.

Even after moving to San Francisco, O'Shaughnessy kept his Mill Valley retreat and remained involved in community affairs. His many contributions to both Mill Valley and the county included a role in the creation of the Marin Municipal Water District. But in Mill Valley, he remains most fondly remembered for his visionary town design, with its footpath system—once described as "10,000 steps hung on the side of Mount Tamalpais." (Courtesy of Marin History Museum.)

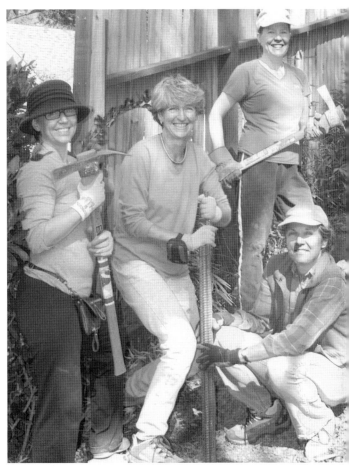

Victoria Talkington, Steward of the Steps

Once cars arrived in Mill Valley, Michael O'Shaughnessy's steps, lanes, and paths—originally designed to accommodate a train-centric community—fell into disrepair. But Victoria Talkington saw the footpaths as a community asset that promoted recreation, community connections, emergency exits, and safe walkways for schoolchildren. In 2002, she organized a group to revitalize the extensive pathway system. The group, known as Step-by-Step, surveyed all of Mill Valley's footpaths, identifying every public step, lane, and path. They then created a map showing all the public pathways and linked it to placards at each pathway entrance. Both the map and the placards featured an illustration by local artist Marianne Sigg. Clean-up and repairs came next. Everyone from Boy Scouts to Rotary Club members threw their backs into the job. Today, residents and visitors alike can explore Mill Valley via passageways with names like Willow Steps and Shady Lane. Victoria continues to steward the maintenance of the pathway system. She is second from left in the photograph with other SL&P volunteers Lisa Feshbach, Maureen Parton (above), and Stephanie Moulton-Peters. (Left, author collection; right, courtesy of *Mill Valley Herald*.)

Richard "Dick" Jessup, Gentleman Visionary

Dick Jessup's positive impact on Mill Valley cannot be overestimated. It began with his 1976 election to the city council. His campaign materials consisted of lawn signs painted by his daughters and a beige flyer. "My tenure as Mayor occurred when the citizens of California passed Prop. 13," Jessup wrote about his time in the role. "It required us to reduce the City budget by one third." He assembled a committee and together they spent late nights "hashing over" where to slice. Throughout the crisis, Dick endured a daily barrage of hostility from upset citizens. Ultimately successful, he praised his committee for coming up with the best recommendations, but the Rotary Club knew who had captained the ship. They awarded Dick the Citizen of the Year award for "[leading] the City out of financial chaos and into its presently strong position."

Mill Valley native and contractor Max McGuinness says Dick saw everything as a team effort. Max worked with Dick on building projects ranging from city buildings to numerous homes and businesses. "The mutual goal was making the best project for everyone," says Max. The best evidence of that objective is the plaza just off the Depot Bookstore and Café. This unnamed plaza was entirely Dick's vision. Dick's longtime friend Ivan Poutiatine recalled, "There was wholesale opposition to the idea by the downtown merchants who feared the loss of nearby parking." But Dick figured out a solution and began to help others see his vision. "He spent a couple of years persuading [the merchants] that an attractive plaza would enhance business," said Ivan. "Slowly, brick by brick, he built up support for the plan." The plaza was completed in 1982 and is now considered the heart of Mill Valley.

Dick died in 2012. He was a visionary leader and a gentleman. Over the years, he served on (and often presided over) numerous committees and boards that produced important improvements to Mill Valley. Several of the town's iconic buildings are the result of Jessup's architectural designs, including the current Depot Bookstore and Café, remodeled in 1987. No one ever saw him lose his temper or even raise his voice. What people remember is his good humor, his quirky poems that praised retiring council members and hardworking staff, his commitment to stay the course despite opposition to any change, and his myriad contributions to Mill Valley as both an architect and a leader. (Courtesy of Kim Jessup.)

Kim Jessup, Carrying the Torch

Kim Jessup (shown here with her father, Dick) was a partner with her father at Jessup Associates Architects, Inc., until his death. She learned from her dad that architects have a responsibility to be involved in their towns because they can envision change in ways that are good for the community. Kim shares her father's sense of humor, as well as his commitment to designing homes for how people really live and to making public space improvements that foster community. Kim has served Mill Valley in numerous ways, including terms as president of the Mill Valley Chamber of Commerce and the Rotary Club, a board member of the senior living community the Redwoods, and a member of numerous civic committees. Her mother, Lyn, continues to live in the house her husband, Dick, so loved. Mill Valley's first mayor, Frank Bostwick, built the house in 1891 and called it "Blink Bonnie." (Above, courtesy of Kim Jessup; below, author collection.)

Dennis Fisco and Kathy King, Quiet Champions

Mill Valley is filled with people who quietly and wholeheartedly give to the town. It is impossible to name them all, but there are two people who can stand in for the others.

"Don't forget Dennis Fisco," said Mill Valleyan Kathy King when research began on this book. "He's 'Mr. Mill Valley.'" Dennis has served two terms on the Mill Valley City Council and on a variety of nonprofit boards and civic advisory committees. He also joined with Mill Valleyans Gary Van Acker and Rich Robbins to found Friends of the Fields, which raises improvement money for all of Mill Valley's sports fields. But it is Dennis's willingness to step in and help wherever he's needed, as well as his seemingly endless knowledge of Mill Valley's citizens that has earned him so much respect in town. (Dennis is pictured at right talking with another familiar Mill Valley face, John Cutler.)

"Don't forget Kathy King," said Sara Pearson, executive director of the Mountain Play. And Kathy's choice to fill the shoes of retiring Mountain Play executive director Marilyn Smith was pivotal to keeping the institution going during those transition years. Kathy King rivals Dennis in her aversion to the spotlight, but ask board members from the Mill Valley nonprofits she has worked for, and they will tell you that Kathy's intelligence and ceaseless optimism was an absolute game changer for those institutions. (Above, courtesy of Penny Weiss; below, courtesy of Milley Awards.)

Vera Schultz, Political Pioneer

Vera Schultz is perhaps most famous for championing the creation of the Frank Lloyd Wright–designed Marin County Civic Center while she was a Marin County supervisor. But many of the county's most significant political reforms and public programs can be traced to Vera Schultz. And it all began in Mill Valley, with a wading pool.

Leaving behind her career as a writer for the San Francisco *Post-Inquirer*, Vera and her husband, Ray, moved to Mill Valley in 1928. But her hunger for the intellectual stimulation she had enjoyed at a metropolitan newspaper did not wane with her move to the quiet village. Beginning in the 1930s, Vera became part of a well-educated group of Mill Valley women who brought chapters of the Association of University Women and the League of Women Voters to the town. Both groups participated in lectures and study groups on significant issues of the day, often held at the Outdoor Art Club in Mill Valley, a collective for the civic-minded women of the town. Vera successfully advocated for a Mill Valley parks and recreation commission, and was one of its first members. But it was when some women from the PTA complained that the city was ignoring their requests to fill a long-empty children's wading pool in Old Mill Park that Vera took her first steps toward what would become a long political career.

The wading pool seemed to Vera an example of an inefficient civic government system—The city council made policies but it was no one's job to implement them. Vera rallied the Mill Valley League of Women Voters to advocate for a city manager form of government that would give the job of implementing the city's policies to a paid professional. The city adopted the city-manager system in 1940. In 1946, Vera became the first woman elected to the Mill Valley City Council, winning 86 percent of the vote. Vera is also credited for organizing a series of land acquisitions that gave Mill Valley an extensive collection of large and small public parks, as well as many recreation facilities. Vera Schultz went on to become the first woman elected to the Marin County Board of Supervisors in 1952.

Vera is remembered as a fearless advocate for more effective civic government, and as a trailblazer for future Mill Valley and Marin County women politicians. (Courtesy of Anne T. Kent California Room, Marin County Free Library.)

**Karen Schurig,
Building Hope Out of Tragedy**
In 1975, Karen Schurig's daughter—a
Tamalpais High School senior—
sustained a traumatic brain injury
in a car accident. She left the hospital
barely able to speak or walk. She
had lost her short-term memory and
struggled with basic cognitive tasks.
Karen, a single mother, found herself
alone and with no information on
traumatic brain injury. Undeterred,
Karen formed a support group and
later a small day program. Twenty-
seven years later, that program is
the Brain Injury Network of the Bay
Area, which provides education on
brain injury prevention and helps
more than 300 brain injury survivors
and their families. (Courtesy of Paige
Schurig Singleton.)

**Anne Layzer,
the Informed Citizen**
No Mill Valleyan is more informed
on political issues than Anne
Layzer, yet she has never endorsed
a Mill Valley candidate or run for
office (though she's been asked
to). That's because she has chosen
to work quietly behind the scenes
for the League of Women Voters
of Marin County. The league does
not endorse candidates, so Anne's
vote remains private. But for more
than 40 years, she has volunteered
for the league with one simple but
profound objective: to help citizens
be well-informed voters. (Courtesy
of Anne Layzer.)

Peter Behr, the Distinguished Gentleman from Mill Valley

Mention the name Peter Behr around those who knew him, and one will hear a wistful sigh, followed by phrases like "such a gentleman," and "Mr. Integrity." It is unlikely to hear such accolades for a politician these days, but this was Peter Behr.

Peter and his wife, Sally, moved to Mill Valley in 1949. In the early 1950s, he got involved in local politics, serving on two Mill Valley commissions and fulfilling one term on the city council. He has been quoted as saying that he loved door-to-door campaigning and that he credited those years with teaching him how to listen to people's concerns and build consensus.

In 1962, Peter was elected to the Marin County Board of Supervisors. His courteous and patient style helped him accomplish a great deal during his years on the board, including the passage of an ordinance that restricted the sale of county-owned land. This included the 18,000 acres around Mount Tamalpais, owned by the Marin Municipal Water District. Because Peter's ordinance required a public hearing before any county land could be sold, it probably saved tens of thousands of acres from commercial development. Fewer than 15 years later, that land became part of an interconnected system of public open space encompassing 50 percent of Marin County.

In 1962, President Kennedy signed a bill creating the Point Reyes National Seashore. But the government did not fully fund the purchase of the land, and that left the project in danger of failing by the time Peter left the board of supervisors in 1969. The widow of Congressman Clem Miller, the bill's original author, implored Peter to take up the cause. That he did. As a private citizen representing local voices, Peter launched the tremendously successful Save Our Seashore (S.O.S.) campaign, gathering support from conservationists to dairy ranchers. Letters were written, politicians were cajoled, and television news crews filmed children cleaning up beaches. A special 57-page "S.O.S." edition of the *Pacific Sun* newspaper was delivered to every legislator in Washington, DC, and a petition with half a million signatures was sent to the White House. On April 3, 1970, President Nixon, with Peter Behr beside him in the White House, signed the bill to fully fund the Point Reyes National Seashore.

Behr went on to serve in the California State Senate and remained involved in conservation issues for the rest of his life. During his years of public service, he also championed the rights of the poor, the mentally ill, and children. Even as Southern Marin County became a stronghold for liberal Democrats, admiration for the Republican from Mill Valley never waivered. Peter died in 1997. He was, in the words of *Pacific Sun* editor Steve McNamara, "a man for all seasons." (Courtesy of Anne T. Kent California Room, Marin County Free Library.)

Huey Johnson, Marty Rosen, Doug Ferguson, and Bob Praetzel, Land for People

Many people who meet Huey Johnson, Marty Rosen, Doug Ferguson, and Bob Praetzel (pictured left to right) have no idea that they are talking to the guys who planted one of the first flags for the modern era of Marin's environmental protection movement.

In the mid-1960s, an East Coast land developer named Thomas Frouge collaborated with the Gulf Oil Company to buy a foggy, windswept parcel of land deep in the Tennessee Valley area of unincorporated Mill Valley. The plan was to develop it into "Marincello," a mixed-use community of 30,000 people. Frouge promoted the project as one that would not add to Marin County's increasingly vexing traffic problem. Marincello, he said, would be a self-contained town where people would live, work, and play—almost like a medieval hilltop village. He never explained why residents would not want to take advantage, instead, of the attractions and jobs in nearby San Francisco. Despite the fact that the land had no existing infrastructure and limited access to water, the proposal moved through the planning process with stunning speed . . . until Huey Johnson found out about it.

Huey Johnson—who then worked for the Nature Conservancy—enlisted fellow Mill Valleyans Marty, Doug, and Bob to help him fight the developers. Attorney Doug Ferguson had recently proven his mettle in a successful waterways battle in Sausalito; Marty Rosen joined on as a concerned citizen; and attorney Bob Praetzel provided his legal services, pro bono, to take the developers to court. Gulf Oil did not take them seriously at first, but as Doug Ferguson put it, Huey's group of rebels were too crazy to quit. Hundreds of volunteers joined the effort, and Praetzel and Ferguson managed to tie up the entire project in county courthouse red tape. Thomas Frouge died suddenly in 1969. Soon afterward, the Goliath oil company conceded defeat. Huey orchestrated the purchase of the land from Gulf, making it the property of the Nature Conservancy until the Golden Gate National Recreation Area—created just a couple of years later—took it over.

The men shared two beliefs: Anything is possible, and people deserve to enjoy access to nature, regardless of where they live. Not long after Marincello, Huey founded the Trust for Public Land (TPL), and went on to work for environmental causes as both a public and private citizen. Both Marty and Doug served on the TPL board. Doug Ferguson remains on the board of the TPL today. And though he firmly believes in the preservation of open space, he is also a vocal advocate for affordable housing. He was the first board president of the Ecumenical Association for Housing, today simply titled the EAH. (Photograph by Lou Weinert, courtesy of Kelly+Yamamoto Productions, copyright 2012.)

Phyllis Faber, a Force of Nature

Phyllis Faber brings her knowledge and appreciation of nature together with a compassion for people in a way that is uniquely hers.

Phyllis moved to Mill Valley from New York with her husband and children in 1962 but was soon back on the East Coast, where she completed her master's degree in microbiology at Yale. After graduating, a teaching position gave her an opportunity to learn about the beauty and complexity of wetland ecosystems, a subject that became a lifelong passion.

When Phyllis returned to Mill Valley in 1970, she soon found herself heading the Marin County campaign for state ballot initiative Proposition 20, establishing the California Coastal Commission. The successful campaign achieved the highest margin of votes for any proposition before or since. The California Coastal Commission holds authority over all matters impacting California's coastal region, protecting it from a variety of negative influences. California state senator Peter Behr appointed Phyllis to be on the first commission.

During her years on the California Coastal Commission, Phyllis learned that West Marin's farmers and ranchers had begun selling their family-owned land to developers, mostly due to uncertainty about the future of farms in West Marin. With her good friend Ellen Strauss, Phyllis created MALT—the Marin Agricultural Land Trust. MALT buys the development rights to small farms and ranches, allowing the owners to maintain an important way of life and to continue providing the region with high-quality, locally produced food.

Longtime political observer Anne Layzer describes Phyllis as a "nuanced environmentalist" who understands things like the difference between wilderness and recreational open space and believes that the work and housing needs of people need not be disregarded in an effort to protect the environment.

For more than 25 years, Phyllis has monitored Northern California marshes, advising state and regional agencies on wetland restoration strategies. Her passion for wetland restoration led her to become a self-educated botanist. In 1982, she wrote *Common Wetland Plants of Coastal California*. Her well-researched book drew the attention of the California Native Plant Society (CNPS) and a request to edit its publication, *Fremontia*, which she did for the next 17 years. Phyllis went on to author and edit numerous books for CNPS and later for the University of California Press. The beautifully illustrated and scientifically accurate books that Phyllis produced line the shelves of both amateur and professional horticulturists, and have positively impacted the move toward sustainable native plant gardening.

Through teaching, writing, editing, and advocacy, Phyllis Faber has spent more than 40 years bringing a deeper understanding of all aspects of California's complex ecosystem to anyone willing to learn. (Photograph by Lou Weinert, courtesy of Kelly+Yamamoto Productions, copyright 2012.)

The Reunion - November 18, 2010
The Redwoods, Mill Valley, CA

Joe Stewart, the Redwoods, Mill Valley's Other Community Center

The Redwoods, Mill Valley's senior living community, is a testament to what a community can accomplish. Unlike many complexes built for older adults, the Redwoods does not make one think of a "retirement home." Instead, it functions more as a second community center for the town. But if it weren't for Joe Stewart's willingness to put his money where his mouth was, the Redwoods might never have been built.

Joe and a few other members of Mill Valley's Community Church conceived the idea for the Redwoods in 1970. They proposed that the church support a senior living community in town, and they formed a committee to research the idea. From the beginning, the project was viewed as a way for seniors to "age in place," with access to various levels of support as their needs increased. The committee also wanted this community to be affordable, regardless of financial circumstances. It struck out in search of a location for the venture.

Committee members identified a piece of property just right for the complex, but the church didn't have enough money to buy it. Joe Stewart was determined to make it happen, however, and so he mortgaged his house to buy the land. The Redwoods welcomed its first residents in 1972.

Since then, the Redwoods has become a freestanding, not-for-profit senior residential community. Its wisteria-draped patio, beautiful lobby, and large auditorium have hosted many community-wide gatherings—including candidate debates, political forums, and celebrations.

In 2010, the Redwoods hosted a board of trustees reunion, bringing together current and former board members representing 38 years of service to Mill Valley's vibrant senior community. (Courtesy of the Redwoods.)

Mill Valley Seniors for Peace, Antiwar Organization
Mill Valley Seniors for Peace is an antiwar organization based out of the Redwoods senior living community. Their average age: 86. Their mission: world peace. The group formed in 2003 in response to the US military's involvement in Iraq. The seniors now work for peace and social justice issues in a variety of ways but are most known for their peaceful protests every Friday from 4:00 p.m. to 5:00 p.m. on the corner of Miller Avenue and Camino Alto. (Courtesy of Suki Hill.)

Elizabeth Moody, Housing as Social Justice

Elizabeth Moody considers affordable housing a social justice issue. The longtime Mill Valley resident first began to work for affordable housing after World War II, when she witnessed housing discrimination firsthand while living in Georgia. As a Mill Valley resident, she became involved with the Ecumenical Association for Housing (EAH), and later formed the Mill Valley Housing Committee, which meets monthly in her current home, the Redwoods. Elizabeth has received many awards for her work to bring more affordable housing to Mill Valley. In 2010, the EAH honored her with the Melvin H. Boyd Award for Outstanding Affordable Housing Advocacy and Volunteer Activism. The mission statement for Elizabeth's Mill Valley committee clearly articulates her belief: "A just society based on mutual respect must not exclude at night those who are part of our common life in the day." (Author collection.)

CHAPTER FOUR

Foundations and Footraces

Much of Mill Valley's character is represented in the endeavors of its service organizations, cultural institutions, and annual events. Collectively, these represent both the traditions and values of the town.

Mill Valley's generosity is evident in its foundations and service clubs. Whether wealthy or working class, Mill Valleyans have always given both money and time to worthwhile causes. Grounded in the altruistic beliefs of Laura Lyon White, the Outdoor Art Club—more than 110 years old—has protected Mill Valley's natural beauty while giving time and money to help those in need. The Art Club has also provided a forum for intellectual discourse and education on civic affairs. The Mill Valley Rotary Club, founded in 1926, has served a similar purpose, and both clubs have proved to be early pioneers for women's rights. More recently, Kiddo (the Mill Valley Schools Community Foundation, founded in 1976) stepped up to ensure that art continues to be taught in public school classrooms, even after the state slashed education budgets to the bone. Kiddo has grown to fund a number of school programs and also hosts popular public events.

Lucy Mercer, of 142 Throckmorton Theatre, and Mark Fishkin, of the Mill Valley Film Festival, give established and emerging artists a venue for their work. These organizations have enhanced the town's artistic and intellectual heritage. And thanks to Abby Wasserman and Trubee Schock, the artists fostered by those organizations are celebrated every year at the Milley Awards.

Mill Valley is a town of celebrations. The annual Milley Awards give Mill Valleyans a chance to dress up, but the Dipsea Race is a decidedly informal affair. The infamous footrace has not only attracted runners for over 108 years, it has drawn hundreds of spectators who line the Dipsea path from Mill Valley to Stinson Beach, doling out water to thirsty racers and cheering them on with words of encouragement. Mill Valley hosts a variety of other festivals. Some, like the annual Memorial Day Parade, showcase the quirkiness and old-fashioned charm that Mill Valleyans are so proud of.

All of these institutions and events have one thing in common—people. Not just the people who benefit from them, but also the people who make them happen. These foundations, festivals, and footraces all exist because of committed leaders of nonprofits and cadres of volunteers, not all of whom will see the fruits of their labor. There is a Greek proverb that says, "A civilization flourishes when people plant trees under which they will never sit." This proverb is certainly evident in Mill Valley's organizations and traditions, many of which—by the way—are enjoyed in the shade of the town's redwood groves.

Laura Lyon White, the Outdoor Art Club

In the center of Mill Valley's downtown stands the beautiful Outdoor Art Club, designed by Bernard Maybeck. The choice of Maybeck—known for his focus on quality craftsmanship and environmental sensitivity—would come as no surprise to anyone who knew the club's founder, Laura Lyon White.

Laura Lyon was a student at Oberlin College when she met her future husband, Lovell White, and followed him to California, where they faced both tragedy and fortune. While running a business in a Sierra foothills mining town, Laura gave birth to two children, only to lose them both to scarlet fever. But also during that time, Lovell White met investment banker William C. Ralston, who offered White a position at the San Francisco Savings Union.

The couple was embraced by San Francisco society, but Laura had little interest in "bridge and gauze bows on luncheon tables." During her years in the mining camp, she had witnessed the destruction of vast forests in the service of industry, and she had seen the horrifying living conditions of the miners. Now, with access and resources, she turned toward the protection of California's redwood trees; the improvement of the living and working conditions for the underprivileged; and the creation of an urban park and playground system. Laura was also active in a number of women's clubs. Before women could vote, these clubs provided them with an important avenue to political influence. As the story goes, it was during this time that Lovell White asked his wife for another child. Laura—by now nearly 40—agreed to have a child if Lovell would support her charitable works. In 1877, Laura gave birth to Ralston White. She later successfully championed an urban park system, numerous social reforms, and legislation that led to the protection of vast groves of redwood trees, including Muir Woods.

When Lovell White became president of the Tamalpais Land & Water Company in the 1890s, he built a summer home in Mill Valley. By 1902, Laura was disheartened by the impact of tourism and development on the hamlet. She did not oppose progress, but she felt it should be well planned. She subscribed to a philosophy known as "the City Beautiful"—a belief that city dwellers needed a healthy and beautiful outdoor environment. So Laura and a group of like-minded Mill Valley women founded the Outdoor Art Club to enhance Mill Valley's beauty and to encourage civic-mindedness. "Outdoor art is democratic and belongs to the people." Laura White once said, "When . . . it finds a permanent home in our midst, civilization will have advanced." (Author collection.)

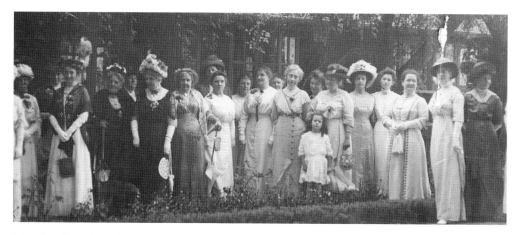

The Outdoor Art Club, Yesterday and Today

When Laura White began the Outdoor Art Club (OAC) in 1902, attire for members was somewhat more formal than it is today, as suggested by the c. 1908 photograph above. Today, women arrive in relaxed casual wear for yoga classes, garden work, and community projects. The clothes may have changed, but the club's mission remains the same: "To preserve the natural scenery of Mill Valley and the surrounding country; to beautify the grounds around public buildings; to work against the wanton destruction of birds and game; to encourage the development of outdoor art; and to engage in other civic, literary, and charitable work." In the photograph below, OAC members take a break from their work to pose under a portrait of Laura White. (Above, courtesy of Outdoor Art Club; below, author collection.)

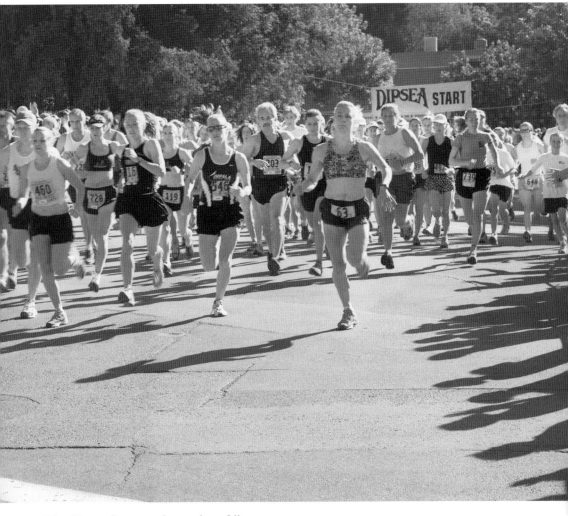

The Dipsea Runners, Legendary All
No annual event in Mill Valley carries more epic tales of victory and defeat than the Dipsea Race. In 1904, two hikers decided to race each other over Mount Tamalpais, running 11 miles from Mill Valley to what is now Stinson Beach. The race became official the following year, open to all who dared enter. With the exception of years skipped during the Depression and World War II, the race has been run every year since it began. Today, the Dipsea covers 7.5 miles, but its distance belies its truly grueling nature. Beginning in downtown Mill Valley, 1,500 runners enter a narrow trailhead in Old Mill Park and immediately run up 671 hillside steps. Ahead of them is a 1,360-foot climb up an uneven and treacherous dirt trail, naturally mined with small boulders and fallen tree limbs. The runners ascend and descend hills with names like "Cardiac" and "Insult." The race uses an age-based handicapping system, making it possible for any entrant to finish first. Many runners strive to win the best time. But for most participants, the real prize is the coveted black Dipsea T-shirt, awarded to the first 35 racers over the finish line. (Courtesy of Skip Sandberg.)

Russ Kiernan, Dipsea Hall of Famer
Mill Valley resident Russ Kiernan ran his first Dipsea Race in 1969 at 31 years old. Until then, he had not been a long-distance runner, but on that day he got hooked. In 2013, the retired schoolteacher ran the Dipsea for the 42nd time at 75 years old. Russ has won three first-place awards, 30 black T-shirts, many special acknowledgement trophies, and an induction in 1999 into the Dipsea Hall of Fame. (Courtesy of Russ Kiernan.)

Reilly Johnson, Centennial Celebrity
The centennial Dipsea Race was held in 2010. Eight-year-old Mill Valleyan Reilly Johnson entered with hopes of winning a black t-shirt. This was her third Dipsea Race. Her handicap gave her a lead over more seasoned runners, but could she hold it? On June 13, 2010, Reilly Johnson not only won a black t-shirt, she won the 100th Dipsea Race, earning a place in history and a plaque with her name on the Dipsea Steps. (Courtesy of Gary Ferber Photography.)

Lucy Mercer, 142 Throckmorton Theatre

Lucy Mercer is a risk taker. That's the conclusion one must come to when learning that she had mortgaged her house in order to purchase and restore the crumbling Hub Theater in 2002.

The Hub Theater had opened in 1915 and was instantly the center of evening life for the community. It offered professional performances as well as amateur variety shows featuring local talent. It also showed films. One Mill Valleyan recalled that both the cream of Mill Valley society and the humblest turned out to view the latest releases at the Hub, all gathering together in a happy, friendly setting. But it closed in 1929. In 1952, it reopened as the Oddfellows Hall, and was often rented out for local events including another community variety show. It also showed "Saturday Night Movies," a precursor to the Mill Valley Film Festival. But eventually the Oddfellows moved out, and the building faced almost certain demolition.

Lucy did not want to see the historic building become just another group of offices, so she bought it and set out to revitalize community life in downtown Mill Valley. She envisioned a place where people would gather together for a shared experience of entertaining and informative evenings—a hub of community life, in fact—and a place for seasoned and upcoming artists to both create and exhibit their work. That's exactly what happened. Today, 142 Throckmorton Theatre is an award-winning arts organization that has a variety of live performances, and includes a youth theater program, a resident orchestra, a playwrights' lab, and a gallery. 142 Throckmorton also provides a small number of studio spaces for artists and writers. The weekly event that most successfully crosses generational lines is *Mark Pitta and Friends*, a comedy night that provides a venue for unknown comedians to get a start, and for veteran comics like Marin residents Robin Williams and Mort Sahl to try out new material.

Lucy is quick to say that she did not do it alone, but if she had not seen the possibilities and taken that initial risk, it would not have happened. Why did she do it? In a 2008 interview she stated simply, "A community needs its artists as much as it needs policemen and firefighters." (Courtesy of Suki Hill.)

Mark Fishkin, Mill Valley Film Festival

When Mark Fishkin first took over the running of "Saturday Night Movies" at the Oddfellows Hall in the early 1970s, he already had dreams of a lifetime career in independent films. In 1977, he and fellow film-lovers Rita Cahill and Lois Cole put together a three-day film festival. The festival received such a positive response that by the following year they had launched the official Mill Valley Film Festival. That first festival, sponsored by the Mill Valley Center for the Performing Arts (later to become the Marin Theatre Company), showed movies in the Oddfellows Hall—outfitted with folding chairs—and held lectures, classes, and receptions at two other venues. One highlighted filmmaker was James Brouhton, whose avant-garde short film *The Bed* featured Druid Heights resident Roger Somers. By 1980, the film festival had expanded to include the Sequoia Movie Theater, with receptions at the Outdoor Art Club. Among the documentaries shown was Robert Carlton's *Survival Run*, about blind runner Harry Cordello, who—with the aid of a friend—ran the Dipsea footrace.

Since those early beginnings, Mark has remained the executive director of the Mill Valley Film Festival, now one of the premiere noncompetition film festivals in North America. He has steered its growth into an 11-day event, selling more than 40,000 tickets and hosting filmmakers from around the world. Mark takes special pride in the role he feels the festival has played in promoting independent films that went on to national fame, films like *The Crying Game* and *My Left Foot*. Even though the festival now plays out over multiple theaters in three Marin County cities, its heart is still in Mill Valley. For 11 days every October, the quiet streets surrounding Mill Valley's downtown fill up with the faces of famous actors, directors and producers, as well as many faces one will not recognize . . . yet. (Courtesy of Tim Porter.)

Abby Wasserman and Trubee Schock, the Milley Awards

Between those who grew up in Mill Valley and those who live there now, it is possible that no town in Northern California has been home to more artists. Whether fine artists, musicians, actors, or writers, Mill Valley has them, and always has.

Abby Wasserman grew up in Mill Valley, coming of age among her parents' group of creative friends. Both she and her brother John became writers, and Abby also worked in visual arts. Abby has remained a Mill Valley resident much of her adult life. In 1987, while serving on the Mill Valley Art Commission, she came up with the idea of an annual award for creative achievement to one Mill Valley artist. The first Creative Achievement Award was given to Ann O'Hanlon as part of a regularly scheduled city council meeting.

When Trubee Schock joined the Art Commission in 1989, she brought with her more than 45 years of experience working for organizations ranging from politics, to art, to history. She used her talent for community building to elevate the achievement awards to an official, city-sponsored, annual event. By 1997, Abby was no longer on the art Commission, but she joined Trubee to work on the achievement awards that year. It was obvious by then that one award per year would not come close to honoring all the talent represented in the town. The Creative Achievement Award—renamed the Milley Awards— therefore grew to honor several Mill Valleyans each year for their work in visual art, music, theater, writing, and contributions to the art community.

The Milley Awards were held in the Outdoor Art Club until the event outgrew the space. Fortunately, in 2001, Mill Valley opened a new community center with an outdoor terrace and vaulted-ceiling grand hall. The Milley Awards moved there. The event is the highlight of the year for many in Mill Valley, who enjoy seeing old friends as they gather to honor those who have kept the town's creative tradition alive. Abby and Trubee remain involved as two of the 14-member Milley Award Board of Directors. (Courtesy author collection.)

Milley Recipients

Scores of Mill Valley's beloved locals have received Milley Awards. This 1998 reunion photograph shows many of those recipients.

Pictured are, from left to right, (first row) Cathy Angelo, Phil Fath, Josepha Fath, Jon Fromer, David Roche, Jeanie Chandler, Charles Meacham, Pirkle Jones, Millicent Tomkins, Zilpha Keatley Snyder, Allester Dillon, Richard Dillon, and Katharine Mills; (second row) Tony Angelo, Carol Cunningham, Joe Angiulo, Cece Bechelli, Leah Schwartz, Joan Deamer, Dave Fromer, Jackie Fromer, Rosemary Ishii MacConnell, Trisha Garlock, Susan Trott, Marilyn Smith, Phyllis Faber, Lettie Connell Schubert, Mark Fishkin, Jeanie Patterson, and Ned Mills; (third row) Dan Caldwell, Barry Spitz, Michael Parra, Steve Coleman, Richard Jessup, Reed Fromer, Jan Pedersen Schiff, John Libberton (sculptor of the Milley statuette), Bob Greenwood, Rita Abrams, Paul Liberatore, Tom Killion, George Leonard, and Chester Arnold.

Milley recipients not shown in this photograph are listed below, alphabetically and as they were identified by the Milleys (through 2013): Steve Bajor, Lonnie Barbach, Eldon Beck, Jack Beck, Jean Shinoda Bolen, M.D, Sharon Boucher, Henri Boussy, Susan Brashear and Ben Cleaveland, Katy Butler, Sue Carlomagno, Don Carpenter, Bill Champlin, Laurie Cohen, Alice Corning, Austin deLone, Depot Bookstore and Café, Jimmy Dillon, George Duke, James Dunn, Zoe Elton, Mimi Farina, Creig Flessel, Nelson Foote, Craig Frazier, Dick Fregulia, Ida Geary, John Goddard, Betty Goerke, Sammy Hagar, Martha Hannon, David Harris, Jon Hendricks, Paul, Stefan and Julian Hersh, Dan Hicks, Suki Hill, Jane Hirshfield, Kristin Jakob, Ann Killion, Fred Larson, Will Marchetti, Gabriella Mautner, Cyra McFadden, Steve McNamara, Gretchen Jane Mentzer, Lucy Mercer, Jean Maguire Mitchell, Richard Moore, Mountain Play Association, David Myers, Alan Nayer, Naomi Newman, Rob Nilsson, Ann O'Hanlon, Si and Max Perkoff, Bill and Elaine Petrochelli, Ivan Poutiatine, Kathleen Quinlan, Robert Royston and Asa Hanamoto, Peggy Salkind, Margaret Sanborn, Lee Sankowich, Trubee Schock, Phil Sheridan, Martin Cruz Smith, Larry Snyder, Ray Strong, The Outdoor Art Club, Gloria Unti, Abby Wasserman, Bob Weir, Ricca Wolff, Kett Zegart. (Courtesy of Milley Awards.)

Larry Lautzker.
Memorial Day Parade
The annual Memorial Day
Parade is where both Mill
Valley residents and business
owners show their funky spirit
with floats and entertainment
created by everyone from
the Tam High Jazz Band to
Happy Feet Dance School.
Current parade organizer
Larry Lautzker owns the
clothing store Famous for Our
Look. At the parade, Larry
and fellow "fashion-police"
hand out fashion violations
from motorized scooters.
Larry is pictured on left beside
Mill Valley's recently retired
police captain Jim Wickham.
(Courtesy of Andy Berman.)

Domenico and Paolo Petrone,
Mill Valley's Winter Festival
For more than 20 years, Mill Valley's
downtown has been transformed
into a winter wonderland for one
day in December, complete with
a snow-covered peewee sled hill.
The festival is put on by Domenico
and Paolo Petrone, owners of
D'Angelos Ristorante, one of three
Italian restaurants in downtown Mill
Valley. Mill Valleyans enjoy the taste
of southern Italy that the Petrone
brothers have provided since 1981. But
in December, they also say thanks to
the brothers for the more alpine vibe.
(Courtesy of Suki Hill.)

Mill Valley's Rotarians, Service above Self

In 1926, the Rotary Club's Chicago headquarters identified Mill Valley as "a mighty good little town . . . which ought to have a Rotary Club." And so it did, chartered in 1926. The Rotary Club's motto, "Service Above Self," has guided its members over the years, attracting some of the most big-hearted Mill Valleyans to its ranks.

In an oral history conducted by the club, George Hoyle (a member from 1958 until his death in 2004) said that one thing he liked about the Rotary Club was how its members put sweat-equity into worthy causes. "We actually did things for people," he said, "rather than paying others [to do them]. We built steps in Mill Valley on a hands-on basis." Today, the Mill Valley Rotary Club still builds steps and hosts slot car races, but it also donates to many charitable causes. A generous bequest left by George Hoyle has funded the Rotary Club's George Hoyle Foundation for many years.

The Rotary Club had a big heart, but until 1987, what it did not have was women. In 1986, Rotary International was fighting a court ruling that prohibited the exclusion of women. But Mill Valley's Rotary Club thought having women members was a good idea. On March 16, 1987 (the year this photograph was taken), the Mill Valley chapter became one of the first clubs in the state to admit women. It got ejected from Rotary International for its trouble. Things worked out in the end, though, and those women—Terri Swenson and Margie Stephenson—became just the first in a long line of female members. (Courtesy of Suki Hill.)

Penny Weiss and Trisha Garlock, Kiddo!
When California's Proposition 13 passed in 1978, school districts across California cut their budgets to the absolute essentials. Art was the first thing to go. But two next-door neighbors, both Mill Valley moms, did not consider art expendable. In 1982, Penny Weiss (pictured on left) and Trisha Garlock (right) formed a nonprofit to fund art in the schools until the money was returned to the budget. They figured that the funds would be restored within five years, tops. Thirty-one years later, that nonprofit—now called "Kiddo!"—still exists. The Kiddo logo, an exclamation point, is displayed on bumper stickers and in store windows all over town. Kiddo is not likely to be closing its doors any time soon. In 2013, the organization had a $2.7-million annual budget and an endowment fund that provided art, technology, and classroom aids to Mill Valley's public schools. Trisha Garlock remained the executive director of Kiddo until her retirement in 2013. Penny Weiss went on to be a volunteer and a professional fundraiser for many Mill Valley nonprofits. (Above, courtesy of Penny Weiss; left, author collection.)

CHAPTER FIVE

The Texture of the Town

If there is one thing Mill Valley has never been short of, it is characters—whether tie-dyed rabble-rousers, quirky inventors, salt-of-the-earth old-timers, or lovely songbirds. Mill Valley has them all, and they really know how to tell a story. Their skill for spinning a yarn can rival that of a mariner or a soldier—and sometimes they have been those things. Mill Valley's story is like a weaving. What is part of the story cannot be undone, and new threads and embellishments are added all the time.

Although this book devotes a specific chapter to businesses, some former businesses are also represented in this chapter because sometimes they transcended that definition. These were businesses that became institutions, a "third place," where locals naturally gathered as part of the community.

The texture of Mill Valley includes rock music, blues, soul, folk, and jazz, performed in venues as diverse as a music club, a store, a park, and a locally-produced variety show. Baseball has been in Mill Valley's blood since the 1890s, and it has bonded the community even in the wake of controversy. The status quo has never really interested Mill Valleyans, and so journalists have freely challenged conventional thinking. And a healthy dose of irreverence has always provided a counter-balance to those people who would take themselves too seriously; this is the home of the preeminent toilet-seat guitar artist, after all.

Mill Valleyans love a party, and many of those parties are block parties. From neighborhoods where skateboards and strollers fill the driveways, to ones where cabins nestle in forested pockets that look and smell like summer camps—neighbors meet up regularly to have a good time. They come with platters of edibles and bottles of wine and they celebrate their good fortune of knowing each other. And if a couple of those neighbors are commemorating their 82nd wedding anniversary, then they are the guests of honor.

People have come to Mill Valley, or stayed there, because the town has always accepted people who see the world in a variety of ways. Be they nonconformists, entrepreneurs, solitary souls, or successful business leaders, somewhere in Mill Valley there is a spot for them. (Just do not leave food wrappers on Mount Tam or reveal the secret shortcut to Stinson Beach.)

And as for the musicians, well, there must be something in the water. The list of music celebrities who live in Mill Valley seems endless. Whether raised there—like Huey Lewis, or a newcomer like 40-year-resident Sammy Hagar, musicians love Mill Valley. And Mill Valley is richer for it. They bring their energy, their talent, and their famous friends into the clubs and fundraising galas of the town, and keep the music going.

Miss Abrams and the
Strawberry Point School Third Grade Class
MILL VALLEY
THE HAPPIEST DAY OF MY LIFE

Rita Abrams, Talkin' 'bout Mill Valley
In 1969, a young music teacher named Rita Abrams climbed into her VW bus and drove across the country from Boston to San Francisco, in search of a teaching job. Not knowing one San Francisco Bay Area town from another, she simply pulled out a map and randomly applied to every school currently accepting applications. Lucky for her, a kindergarten teacher at Mill Valley's Strawberry Point School had extended her leave of absence at the last minute. Rita got the job.

On Christmas Day that same year, Rita sat on a downtown bench and marveled at the mild winter weather, the natural beauty, and the friendliness of the people. "This town needs its own song," she decided, and so she wrote "Mill Valley," and taught it to her kindergartners. The sweet and sentimental lyrics described a town where "people aren't afraid to smile," "there's a mountain that belongs to everyone," and "creeks run on endlessly."

Not long after the kids learned the song, Rita met a music producer, and told him about it. When he heard the song for himself, he wanted to make it a record. But kindergartners, it turns out, do not sing so much as yell, and so the more musically reliable third grade class stepped in. The 45 recording of *Miss Abrams and the Strawberry Point School Third Grade Class* singing "Mill Valley" hit the airwaves. No one could have predicted what followed.

In 1970, with the Vietnam War creating thousands of homesick young soldiers overseas and evoking political unrest back home, a song about an old-fashioned town where "you can be as friendly as you want to be" struck a chord with radio listeners from South Carolina to military bases in Southeast Asia. "Everybody has a Mill Valley in their heart," one soldier wrote to Rita.

The song made it to the top-100 hit list of *Billboard* magazine and became a music video made by then-local filmmaker Francis Ford Coppola. *Life* magazine wrote about Miss Abrams and her third-grade chorus and so did *Rolling Stone,* who sent out staff photographer Annie Leibovitz to take their picture. The following year, Miss Abrams and her now fourth-graders recorded a full album.

Rita—who still lives in Mill Valley—went on to become an Emmy-winning songwriter. But for Mill Valleyans, her greatest success would always be the day the city council proclaimed *Mill Valley* to be the town's official song (see page 10). (Both, courtesy of Rita Abrams.)

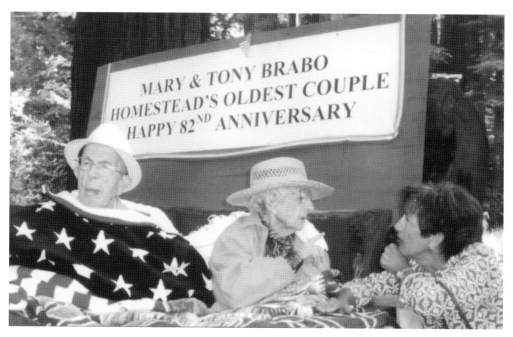

Mary and Tony Brabos, Descendants of Mill Valley's Portuguese Heritage
Mary and Tony Brabos met in 1929 at a Portuguese Holy Ghost Festival, and danced the traditional "Chamarita" together; they were both Mill Valley natives and descendants of the Portuguese's dairy farmers of the 1800s. Mary and Tony married and lived the rest of their lives in Mill Valley. In this photograph, they are celebrating their 82nd wedding anniversary. (Courtesy of Chuck Oldenburg.)

Don Hunter, Local Boy
Don Hunter grew up in Mill Valley's Sycamore Park neighborhood. As an adult, he wore a number of hats in service to his hometown, and he watched a lot of civic history being made. He was director of parks and recreation when Jenny Fulle fought to become the first girl to play Little League in 1972. Twenty-five years later, he was the city manager when the ribbon was cut for the 37,000-square-foot community center. Don retired in 2006. (Courtesy of Mill Valley Community Center.)

79

Fran and Frank Dittle, Mill Valley in Transition

In 1927, 13-year-old Frank Dittle, a typical Mill Valley resident of the era, helped build the house on Walnut Avenue that he would grow up in while spending many boyhood hours hunting quail and deer in nearby Homestead Valley.

In the 1940s, the local newspaper tracked the goings on of all the townsfolk, and Frank's wedding to sweetheart Frances Guth warranted four paragraphs, since the next day he was shipping out for service in World War II. Like all the young soldiers who left their Mill Valley home during World War II, Frank returned to a town much changed during his years away.

In January 1946, the paper reported Frank's return to a happy Fran, who had waited for him for "four years, six months, and eleven days." While away, Mill Valley had grown up around the Walnut Avenue house. Tracks of new homes, built to accommodate returning GIs, had sprung up just beyond Frank and Fran's modest stucco dwelling, and Frank's boyhood pastime of quail and deer hunting had come to an end. But Frank and Fran happily remained on Walnut Avenue, raising five boys ("with only one bathroom," Frank once boasted) and celebrating 63 wedding anniversaries in that home. (Both, courtesy of George Dittle.)

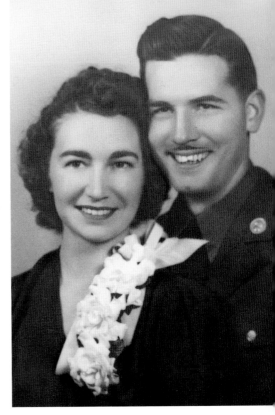

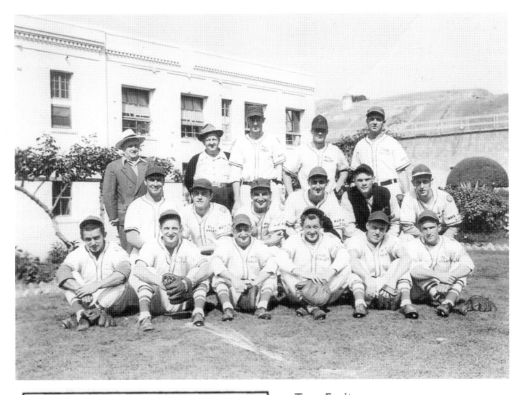

REDLEGS PITCHER

Tony Freitas

Tony Freitas

Diamond Greats 1979 # 255

Life-	IP	H	ERA	W	L
time	518	614	4.48	25	33

Tony Freitas,
Mill Valley's Baseball Legacy
Ever since the Hill Dwellers played against
the Flatlanders in 1900, Mill Valley has
been a baseball town. By 1910, the first
semiprofessional team was formed, playing
for coins that were collected by passing the
hat among spectators. Even town burgher
Ralston White played on a team (Ralston
loved baseball and often hosted softball
games on the lawn of his estate.) Over
the years, Mill Valley was home to several
semiprofessional teams, including the Mill
Valley Merchants (pictured above). In the
1930s and 1940s, the town had four native
sons playing minor league baseball, Tony
Freitas among them. Tony was the son of
Portuguese immigrant and Mill Valley dairy
farmer Antonio Freitas. He became Mill
Valley's first hometown boy to play major
league baseball, first for the Philadelphia
Athletes and then the Cincinnati Redlegs.
(Above, courtesy of GoodOldSandlotDays.
com; left, author collection.)

Ned White, Mill Valley Little League

The end of semiprofessional baseball in Mill Valley did not end the town's love of the game. Mill Valley Little League (MVLL) began in 1954. The first year, there were only two teams, the Yankees and the Indians, but it grew. Today, on the fourth Saturday of March, more than 1,000 miniature "Muckdogs," "Iron Pigs," "Yankees," and "Giants" assemble in front of Old Mill School and then proceed down Throckmorton Avenue in the annual Mill Valley Little League Opening Day Parade. With a Mill Valley Fire truck, a Boy Scout color guard, and a bagpipe band heralding their arrival, they march to Boyle Park, holding the banners of their local sponsors.

At the end of the parade every year, one will find Ned White, who runs the concession stands at Boyle Park. As Dennis Fisco put it, "Ned has been the heart and soul of MVLL for over 25 years now. He is all things MVLL and lives and breathes the program—so much so that he now is a regional representative for Little League. As board members transition through the program there has always been one constant—Ned!" (Both, author collection.)

Jenny Fulle, Game Changer

At Mill Valley Little League sign-ups in the spring of 1972, a quiet boy with a baseball cap pulled over his eyes waited in line, but when the volunteer asked for a birth certificate, he left. The kid knew a birth certificate would squelch any chance to get on a Little League team. He, it turns out, was a she—Jenny Fulle. Jenny just wanted to play baseball, but in 1972, girls were not allowed to play Little League.

Undeterred, Jenny appealed to the park and recreation commission. When the commission voted against her, she wrote to President Nixon, drawing a response from the US Department of Health, Education, and Welfare. The letter said that under the Title IX amendment to the 1964 Civil Rights Act she might have a case. The exchange caught the attention of the National Organization for Women and the American Civil Liberties Union (ACLU). The ACLU argued Jenny's case before the Mill Valley City Council. The city voted yes, then no (under pressure from Mill Valley Little League) and then yes again, and the National Little League threatened to decertify the local league if it allowed girls to play. Ultimately, a superior court judge issued a restraining order, prohibiting Mill Valley Little League from excluding Jenny from the current season. On April 10, 1974, a 12-year-old Jenny Fulle stepped up to the plate for her first practice.

Many in Mill Valley supported Jenny from the start, but some did not. She endured heckling and threatening phone calls. And the harassment continued from the stands, mimicking scenes from the movie *The Bad News Bears*. Ironically, the name of Jenny's team was the Bears. Jenny took it all, and the world changed. In December 1974, the National Little League program opened up to girls.

In 2000, Jenny accepted the invitation of the City of Mill Valley to throw out the ceremonial first pitch at the Little League Opening Day festivities. Writing of the momentous occasion, local resident and writer Jim Schock praised Jenny's courage and fortitude. "It is the observation of many, and I heartily agree," wrote Schock, "that Jenny has had more influence on American society than any other resident of Mill Valley. [She] has directly affected the lives of hundreds of thousands of girls who now participate in an organization . . . formerly chartered exclusively 'for boys'." (Courtesy of Jenny Fulle.)

Steve McNamara, the *Pacific Sun*

In 1966, Steve McNamara picked up a copy of a raggedy-looking but well-written weekly newspaper called the *Pacific Sun*. His life changed forever. The San Francisco newsman, who already lived in Mill Valley, thought the scrappy newspaper could be another *Village Voice*, and he asked about joining the staff. Instead, the current owner sold the paper to Steve and then took off to live on a berry farm in Washington State. Steve moved the operation from Stinson Beach to Mill Valley and took the *Pacific Sun* to award-winning heights. The liberal alternative weekly reported on the emerging environmental movement, the Vietnam War, and many social justice issues. The *Pacific Sun* also had its offbeat side, with features such as a column by "Dr. Hip Pocrates," giving advice on sex and drugs. Steve met all of the most famous and infamous from Marin's crazy 1970s, including resident philosopher cum hipster-bon vivant Alan Watts. Pictured above (from left to right) Steve McNamara, Dr. Hip Pocrates, and Alan Watts. Steve sold the *Pacific Sun* in 2004 and now advises San Quentin penitentiary inmates about their newspaper the *San Quentin News*, the only inmate-produced newspaper in California. (Above, courtesy of Steve McNamara; below, author collection.)

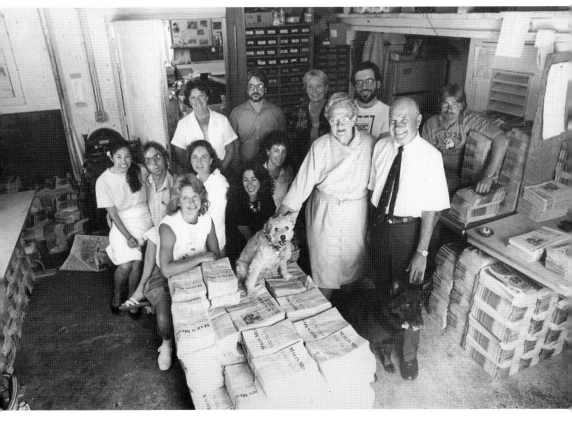

Katharine and Ned Mills, the *Mill Valley Record*

Some of Mill Valley's most notable personalities have stories that begin with "I didn't even know that Mill Valley existed until the first time I saw it." Katharine and Ned Mills are two of those personalities. Both seasoned newspaper veterans, the Mills came to California from Chicago in 1963, hoping to fulfill their dream of running a small-town paper. They looked at newspapers for sale all over California, but it was not until a sales broker suggested that they take a look at Mill Valley's newspaper that they drove into town. It was love at first sight. They bought the weekly *Mill Valley Record*, located across the street from city hall. Their first order of business was to convince the city council to change the night of their meetings to Monday in order for the *Record* to report on the meeting in its Wednesday edition.

Ned handled the business and sales aspects of the *Record*, and had a gregarious personality. Katharine oversaw the editorial end. She also mentored young men and women who went on to write for larger publications. One of those writers was Anne Solem (who would much later serve as mayor in Mill Valley). Anne recalled that even though the Mills arrived from Chicago with no real experience in California, they immediately planted deep roots and learned about the issues. "Katharine made the paper a real reflection of the community," says Anne. "When you read the paper you not only knew what was going on but you also had a feel for the essence of Mill Valley, whether it was rock poster artists or the Outdoor Art Club. Katharine was a joy to work with, too." Anne went on to write for the *Marin Independent Journal*, and later became a managing partner in a communications-consulting firm.

During the Mills' tenure, the *Record* reported on local issues with a gusto that had not previously been part of the paper. The traditionally conservative *Record* took on a more moderate tone under Katharine's guidance, sometimes even a liberal one by the standards of the day. The paper's positions on issues such as affordable housing, women's rights, and sometimes-controversial town improvements were not always popular. But, when the Mills sold the paper in 1987, many people felt they had lost an important local voice. (Courtesy of Suki Hill.)

Dick Spotswood, "Militant Centrist"

Longtime townsman Dick Spotswood is officially a political wonk. The three-term city council member and former mayor helped launch the planning of the new community center, and after leaving office in 1992 he served on a number of county commissions and advisory committees. For six years, Dick voiced his political observations in a column for Marinscope Newspapers. In 2003, he moved to the *Marin Independent Journal*, where the self-described "Militant Centrist" writes twice-weekly columns and maintains a popular blog. (Photograph by Robert Tong, courtesy of *Marin Independent Journal*.)

Peter Coyote, Activist, Actor, Author, and . . . Priest?
Peter Coyote has lived continuously on Mill Valley's Coyote Ridge since 1984, but as far back as 1964, when he was a graduate student living in San Francisco, he often spent weekends riding his motorcycle on Mount Tamalpais. In the mid-1960s, he left school to join the political theater company the San Francisco Mime Troupe and later became a member of the Diggers, a contingent of anarchists challenging every conceivable social convention. Even after becoming a successful actor, Peter remained politically active—both from outside the system and from within it. Peter published his memoir *Sleeping Where I Fall* in 1998. The book recounts his story, and the story of the volatile 1960s. Today, Peter's distinctive voice can be heard narrating documentaries such as Ken Burns's *The Dust Bowl*. A longtime Buddhist, Peter recently became ordained as a Buddhist priest in the layman lineage, and is part of Mill Valley's strong Zen Buddhist community. (Photograph by Chris Felver, courtesy of Peter Coyote.)

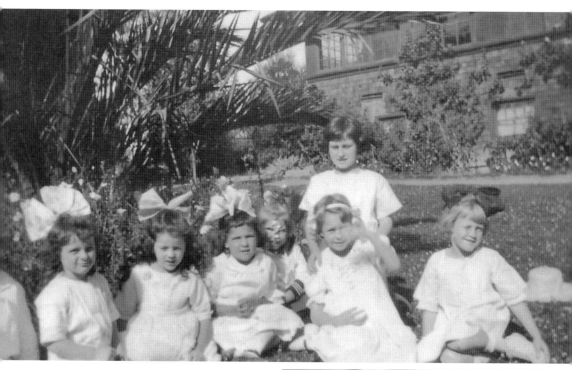

The Roux Goddard Family, Setting Down Roots

The majority of people who bought land in the 1890 auction used the property to build summer cottages, but some lived full-time in Mill Valley right from the start. One such couple was May and George Roux. George, a French immigrant, and his Irish wife, May, moved to Mill Valley from the East Coast in the 1890s and George made the arduous train and ferry commute to his San Francisco business five days a weeks. Whatever it was about Mill Valley that initially attracted May and George must have been very strong because they never left. By 1911, they had built a graceful Craftsman-style home on Sycamore Avenue (still standing today). That is where their children were born, including Lorraine, pictured above (far right) celebrating her birthday in front of the Sycamore house. Lorraine Roux married Andrew Goddard in that house, and they raised their own children in Mill Valley. One child, John, (pictured at right at four years old) would grow up to play a role in Mill Valley's rock music legacy. (Both, courtesy of John Goddard.)

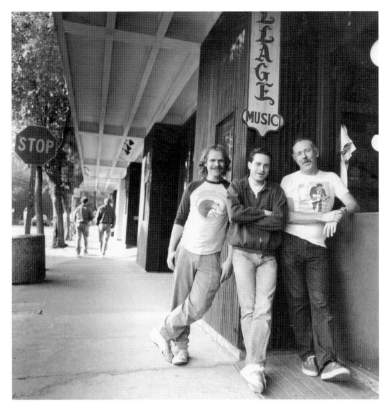

John Goddard, Conductor of Musical Life

Though the record store Village Music—with its Cab Calloway logo—closed in 2007, no one in Mill Valley really thinks of it as gone. This is partly because the store's history carved a lasting imprint into the town, but it is also because its owner, John Goddard, is not gone. Far from it.

John Goddard (far right, standing with Gary Scheuenstuhl, left, and David Sinkkonen, center) grew up in Mill Valley, living his teenage years like a scene out of George Lucas's early film *American Graffiti*. John had a 1960s teenager's love of music, too. He went to his first live concert (Little Richard) when he was only 13. But unlike so many of his peers, John's love of music was not limited to rock and roll. He collected and listened to all sorts of music, and this insatiable hunger led him to a part-time job in a small Mill Valley music shop called Village Music. In 1967, John took over the store, not knowing then that he would transform it from the modest music and instrument shop that it was into a "must stop" destination for many popular musicians doing a gig in San Francisco.

From the beginning, his secret was selection. Unlike many independent record shops in the 1960s and 1970s, John's shop did not specialize in one kind of music. He sold rock, blues, jazz, classical, and timeless vocal artists like Frank Sinatra. Great musicians love all kinds of music, and so in no time John was getting visits from Carla Thomas, B.B. King, Tom Waits, Elvis Costello, and his favorite musician, John Lee Hooker. All the local music legends living in the area—like Jerry Garcia, Carlos Santana, Bonnie Raitt, and Huey Lewis—not only frequented John's store, they played in it from time to time. They also played at the many parties he held over the years at Sweetwater, a popular music venue and watering hole. This helped to solidify Mill Valley's reputation as an important part of the Bay Area's popular-music culture.

John still lives in Mill Valley, selling and trading music as a hobby now, and is very much a presence on the streets and in the coffee shops around town. But people miss being able to drop by his store to participate in the daily discussions about great or rising musicians that went on behind Village Music's Dutch door. (Courtesy of Suki Hill.)

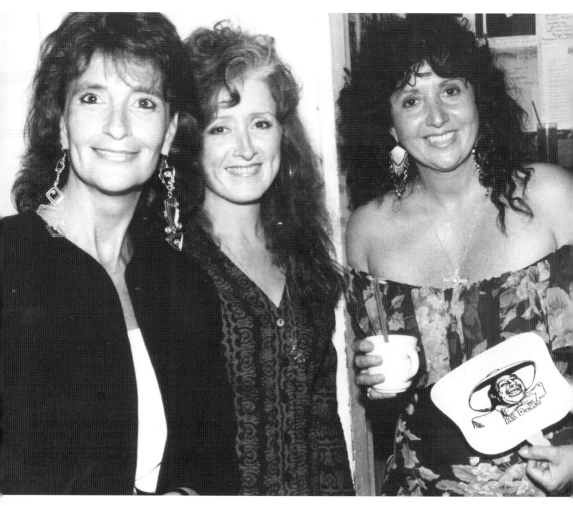

Jeanie Patterson, Sweetwater
Mill Valley has long held the reputation of being a cool place to live, a place where one could have a rock legend for a neighbor. Many things contributed to this image over the years, not the least of which was Sweetwater, a local watering hole that offered live music. For nearly 30 years, Sweetwater pulsed with the bass-beat of amplified music seven nights a week, all under the supervision of Jeanie Patterson (left), an impresario with a keen eye for new talent as well as strong connections with headlining San Francisco musicians. Sweetwater was the recording set for two Hot Tuna albums, and a regular venue for performers like Elvis Costello and John Lee Hooker. Any night at Sweetwater could feature a premier performance or spontaneous set by any number of headlining talents, including Mill Valley residents like Bonnie Raitt (center) or Maria Mauldaur (right). Sweetwater closed in 2007. (Courtesy of John Goddard.)

Austin de Lone, the Musician's Musician
Austin de Lone has lived in Mill Valley since the 1970s, and Mill Valley has benefitted from Austin's extraordinary fluency in virtually every modern musical genre. Austin's first well-known band, Eggs Over Easy, is considered the beginning of the "Pub Rock" music style, and since then he has headlined with many famous bands and other musicians. But no matter how busy or successful, he has always had time for his hometown. He often performed at the original Sweetwater and functioned as its musical director on open-mike nights. He is one of the current members of Christmas Jug Band, an assemblage of musicians that includes many local artists. (Courtesy of John Goddard.)

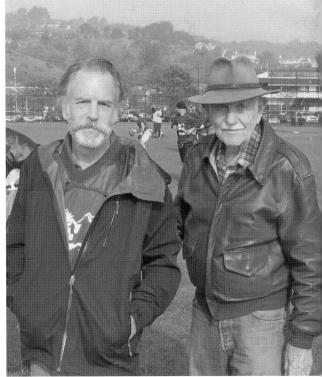

Bob Weir, the New Sweetwater
When Sweetwater closed in 2007, it left a huge hole in the heart of Mill Valley. But some time after that, rumors began that Mill Valley resident and former Grateful Dead guitarist Bob Weir had gathered a group of investors to help him reopen the music venue. It was true.

In January 2012, the Sweetwater Music Hall, newly situated in the remodeled ground floor of the Mill Valley Masonic Hall, turned on its amplifiers and swung open its heavy black doors. The much spiffier music hall lacks its namesake's funky, hole-in-the-wall character. But the music is back downtown. Bob (left) is pictured with his father, Jack Parbour, also a Mill Valleyan. (Photograph provided with permission, copyright Russ Eddy, www.russeddy.com.)

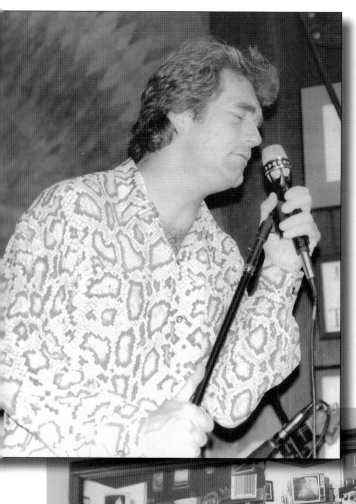

Huey Lewis, the Heart of Rock and Roll

Mill Valley is home to many rock-and-roll musicians, but only a few grew up in the town. One of those is Huey Lewis. The local boy went through Mill Valley's elementary school system, beginning at Strawberry Point. Huey traveled and played music for a number of years before the harmonica-toting singer found his sound with his band Huey Lewis and the News. Huey returned to live in Mill Valley and Marin County for a number of years and was known to turn up for jam sessions at the old Sweetwater. He shot the cover of his 1983 album *Sports* inside Mill Valley's 2a.m. Club. The News has had many hit songs and records, but their song "The Heart of Rock and Roll," is an anthem. A signed copy of the platinum-winning *Sports* album hangs on the 2a.m. Club wall. (Left, courtesy of John Goddard; below, author collection.)

**Sammy Hagar,
the Red Rocker**

If someone were to run into Sammy Hagar on the streets of Mill Valley, she might not suspect he was a bona fide rock star. Sammy's friendly, approachable style just does not sync with one's image of a hard rock icon. But Sammy Hagar has never been one to conform to expectations.

Sammy Hagar has lived in Mill Valley for 40 years. His trademark corkscrew curls show up in photographs taken as far back as the early days of Sweetwater (shown in the top photograph with Annie Sampson) and as recently as the Milley Awards, where he was honored in 2011 (shown in the bottom photograph with fellow Milley recipient Rita Abrams).

Sammy's years with the band Van Halen got him inducted into the Rock and Roll Hall of Fame in 2007. The hall of fame credits Sammy for the band's first number one hit record, *5150*.

Sammy continues to rock the music. He has also expanded into the restaurant business, including his chain of Sammy's Beach Bar & Grills, which raises money for his Hagar Family Foundation. The foundation helps a number of children's charities. (Top, courtesy of John Goddard; bottom, courtesy of Milley Awards.)

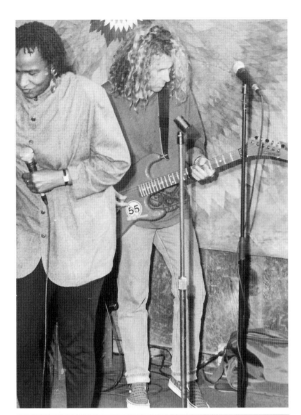

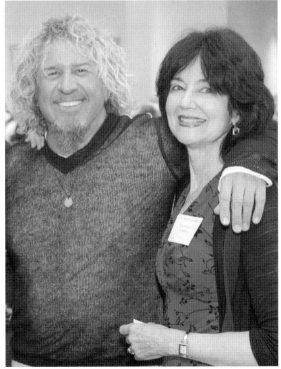

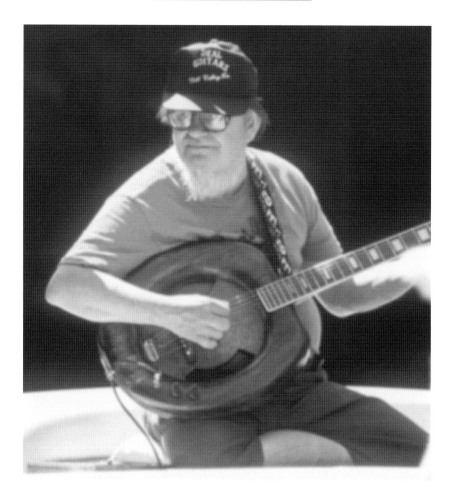

Charlie Deal, "the Legend of Toilet-seat Charlie"

The legend of Charlie Deal began with a toilet seat. The Minnesota native and hardcore rock-and-roll lover arrived in Mill Valley in the 1950s. Charlie was an amateur musician and had harbored a desire to build guitars since childhood. In 1965, it struck him that he might—literally—be sitting on a good idea for materials. His first toilet seat guitar did not get a wholehearted welcome. "Originally I couldn't give them away," Deal is seen saying in Jeremy Keller's short documentary *The Legend of Toilet-seat Charlie.* "Everybody in town was laughing at me and thought I was screwy." But Charlie stuck with it. By the 1970s, his guitars were in high demand. One can even be spotted on the cover of the Huey Lewis and the News *Sports* album cover, shot in Mill Valley's 2a.m. Club.

Charlie's legendary status came from his good nature as much as his unusual guitars. Dubbed the "Unofficial Mayor of Mill Valley," Charlie was so beloved that he even had his own float in the Mill Valley Memorial Day Parade. (Courtesy of Joseph Greco.)

Dan Hicks, Wit and Style

If looking for someone to represent the eclectic character of Mill Valley, one need look no further than the sharp-witted, snappy-dressing musician Dan Hicks, a longtime resident of the town.

Dan's musical career began with the mid-1960s band the Charlatans. Often described as the first "Psychedelic Rock Band," the Charlatans also ushered in the fashion so associated with Haight-Ashbury at that time—layers of Victorianesque costumes, feather boas, velvet hats, and other assorted plumage. By the early 1970s, Dan's new band, Dan Hicks and His Hot Licks, had put the singer into the national spotlight. The Hot Licks provided Dan with the perfect platform to showcase his diverse range of musical styles and his droll humor, with songs like "How Can I Miss You if You Won't Go Away." His sound can be heard in movie and television soundtracks, including the movie *Class Action* and the television series *The Sopranos.* Dan's success continues, both with other bands and in solo performances, and recently, his reinvented version of the Hot Licks has emerged.

Dan's music—with elements ranging from swing-jazz to country—remains fresh. He has generously donated his talent to many Mill Valley fundraising events, and he often performs with the Christmas Jug Band, a Mill Valley holiday tradition for nearly 30 years. (Courtesy of the Milley Awards.)

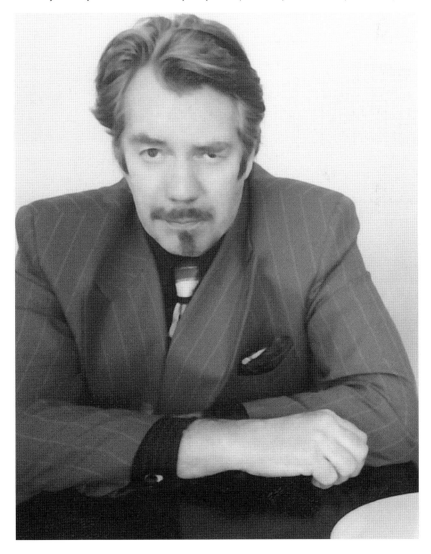

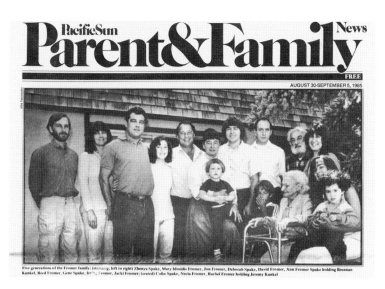

Five generations of the Fromer family: (standing, left to right) Zhenya Spake, Mary Idosidis Fromer, Jon Fromer, Deborah Spake, David Fromer, Ann Fromer Spake holding Brennan Kunkel, Reed Fromer, Gene Spake, Irving Fromer, Jacki Fromer; (seated) Colin Spake, Necia Fromer, Rachel Fromer holding Jeremy Kunkel

The Fromers, Expanding the Definition of Family

This 1985 article in the *Pacific Sun* celebrates five generations of the Fromer family living in Mill Valley at the same time. The article went on to say how close-knit the Fromers were. And close-knit, they remain.

Irving (with the white beard) and his wife, Katherine (not pictured), had been political activists since the 1940s and raised their three children—Dave, Jon, and Ann—to share those values. The couple moved to Mill Valley in the 1950s, and eventually their adult children all followed them there. The extended family stayed strong, and each of Irving and Katherine's children followed their parents' example of working for social justice and building community connections. Building community was important to the Fromer children, and one way they sought to strengthen those connections was through an annual community variety show. In the 1980s, Dave and his wife, Jacki, began an annual variety show that brought together many of Mill Valley's most enthusiastic and talented residents. The weekly rehearsals were as much fun as the shows. The photograph below features many of the regulars at those rehearsals, which were held at Dave and Jacki's home. One participant was Rita Abrams (center), one of many local contributors to Mill Valley's musical heritage. (Above, courtesy of the *Pacific Sun*; below, courtesy of Jacki Fromer.)

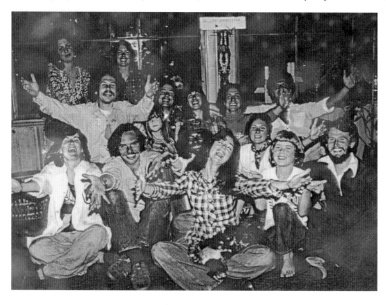

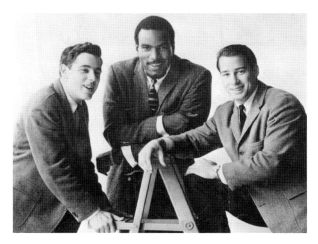

Dave and Jon Fromer, Serving Two Communities

In their youth, Dave and Jon Fromer had been part of a three-man folk-music group that included their friend Elbert Robinson. They traveled the country, sharing billing with names like Henri Mancini and the Beach Boys. After the group broke up, the brothers followed their parents to Mill Valley and contributed their talents to their community.

Jon Fromer (above, left) marched for civil rights in Selma, Alabama, when he was only 19 and remained politically active his entire life. He lent his talent as a singer and songwriter to both local and national causes. He became a television producer in San Francisco and created engaging children's programs and news features on important local issues.

In 1961, Dave Fromer (above, right; below, center back) played soccer on the first San Francisco youth club team to win a National Championship. As an adult, his love of the game inspired him to start the first Mill Valley soccer league, now one of Mill Valley's most popular youth sports. Dave's musical background has enriched his community. It helped him produce Mill Valley's variety shows held through the 1980s and to teach music in the schools. And his guitar playing has been a noted feature of his Saturday morning peewee soccer club for many years. Dave continues to direct a popular youth soccer camp. His work in community sports and youth programs has earned him many awards and a Mill Valley proclamation declaring July 21 to be David Fromer Day. (Both, courtesy of Jacki Fromer.)

Joe Breeze, the Mountain Bike
Mill Valley—with its fire trails on and around Mount Tamalpais, and its easy access to the rest of Marin—is a popular gathering point for weekend mountain bikers. So it should come as no surprise to learn that a Mill Valley native, Joe Breeze, created the first mountain bike prototype. Joe's 1977 "Breezer 1," is now in the collection of the Smithsonian Institution National Museum of American History. (Photograph by Larry Cragg, courtesy of Joe Breeze.)

Sumo Cyclists Club, Mountain Biking
SUMO (short for SUnday MOrning) is a small mountain biking group, founded by locals Bob Engman and Rich Evatz. They range in age from their early 50s to 75, and have been meeting at the same corner café location every Sunday for over 18 years. Their rides take them anywhere from straight up Mount Tamalpais all the way to Point Reyes Station. And they do it in rain, shine, and the rare Marin snowfall. (Courtesy of SUMO.)

CHAPTER SIX

First Among Equals

The people who step into roles of service to Mill Valley have made a decision to do something difficult, and often frustrating. Whether hired, elected, or appointed, they have made themselves responsible for some aspect of service to the community as a whole. They have chosen to subject themselves to criticism when a member or segment of the community is unhappy—whether they are personally responsible for the problem or not. So who deserves to be in a chapter about such people? They all do. Because regardless of how well they did their job, these people chose to serve Mill Valley, often making personal sacrifices to do so.

At the 2013 "Redwoods Celebration of Service Awards," Mayor Andy Berman said that the teachers being awarded that night were "The First Among Equals," meaning that while they were chosen for excellence in their field, they also represented a tradition of outstanding Mill Valley teachers. This can be said for all the people in the following pages. Their stories speak for many, many others.

The City of Mill Valley's citizens elect the city council, and the council sets direction and policy for the city. The mayor is not elected separately; he or she is chosen by the council on an annual basis. The mayor has no authority to override the votes of the other council members, but he or she does have additional responsibilities, including being the public face of the city for that year.

Mill Valley has a city-manager form of government. This means the city council only hires two people, the city attorney and the city manager. The city manager is responsible for implementing the policies set out by the council and for hiring all department heads. This person also has an important role in setting the tone of discourse in the community. The system has been in place since Vera Schultz felt that leaving elected officials in charge of implementing long-term policies and getting things fixed was not the best way to ensure quality and continuity in civic planning.

And then there are the schools. Mill Valley's school district operates independent of the City of Mill Valley. The school district (kindergarten through eighth grade) covers "Greater Mill Valley" (the entire 94941 zip code). Tamalpais High School—"Tam High" as it is always called—also has students from the incorporated and unincorporated communities of Sausalito, Marin City, Muir Beach, Bolinas, and Stinson Beach.

And finally, there are the students. While not members of the groups that serve Mill Valley, they are a product of how well those groups are doing. The success of the community's students is evidence of innovative and effective teaching programs designed by compassionate teachers, youth outreach by the police department, inclusive city council policies, and the after-school programs and sports facilities of the city's parks and recreation department.

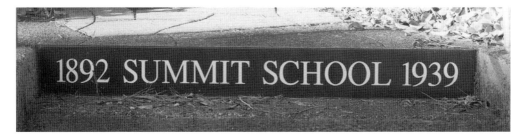

Mill Valley's Teachers, More than 100 Years of Excellence

Summit School opened in 1892. Though nothing remains of it today but two commemorative plaques, Summit was Mill Valley's school until 1939. At least one old-timer claims that a person cannot really say he is a native Mill Valleyan unless someone in his family went there.

Since those early days, Mill Valley schools and the teachers who work in them have regularly received awards from the regional to the state level. But receiving the "Redwoods Celebration of Service, Elizabeth Terwilliger Award," given out every year, makes for a particular honor because it is recognition of teacher excellence by the teachers' own community. The 2013 honorees are just a sample of Mill Valley's many fine teachers. From left to right, they are (first row) Mary Whitney of Tamalpais Valley; Sara Stoelting and Edna McGuire; and Jeanne Temple of Mill Valley Middle School; (second row) Erin Conklin of Park; Cathy Cohen of Strawberry; and Erica Dowell of Old Mill. Not pictured is Christina Amoroso of Tamalpais High School. (Both, author collection.)

Park School Students and Teachers, Hats Full of Ocean Love
Every public school in Mill Valley has innovative programs, many of which serve as models for other school districts. One example of such a program is Park School's Oceans Week. For more than 20 years, the entire Park School student body has spent a week every spring studying the ocean and the bodies of water connected to it. The current curriculum comes from Lawrence Hall of Science's MARE (Marine Activities, Resources and Education), which Park teachers supplement with their own knowledge and activities. The week concludes with a school-wide assembly featuring the environmental-awareness music group the Banana Slugs String Band. Each class of students performs one ocean-themed song written by the band. The highlight of the show is the display of hats that the students decorate in concert with their respective subjects, such as marshes, tide pools, or the open ocean. In these photographs, Kim Kirley's kindergarten class (two kindergartners are pictured above) and Joe Martini's third-graders show off their creations. Kim and Joe are sitting on the stage, to the right. (Both, author collection.)

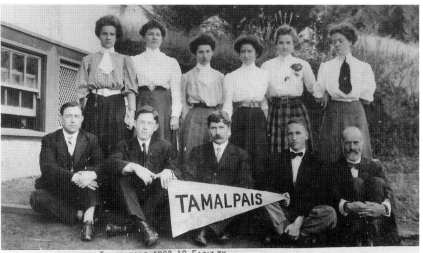

FRONT ROWW THE ENTIRE 1909-10 FACULTY
 THE ENTIRE 1910 GRADUATING CLASS WITH ONE MEMBER OF THE 1909 CLASS

 FRANK INGERSOLL CLASS 1909 2835 BENVENUE, BERKELEY
 HAROLD JOHNSON CLASS 1910 FORT RUGER, HONOLULU
 ERNEST EVERETT WOOD (1908-1909 RETIRED 1944 DIED 1955
 SEDGLEY JORY CLASS 1910 ROUTE 1 BOX 427 NEVADA CITY CALIF.
 A. GUILLOU (1909-10 1940-11
BACK ROW, L TO R
 IRMA SMITH CLASS 1910
 MISS ELIZABETH KAISER (1908-09 RETIRED 1945 DIED 1953
 MISS SCHONE KURLANDZIK (1908-09 RESIGNED 6/30/17
 MISS GRACE PACK (1908-09 RESIGNED 6/30/13
 RAMONA NILSON CLASS 1910 (MRS. J.W. POWER, FERN CREEK LODGE
 LEVINING, MONO CO.
 MAUDE HENDERSON CLASS 1910 (MRS. NORMAN C. ORTMAN, 24 MILLWOOD, M.V.)

Ernest Everett Wood,
Mill Valley Opens its Doors

Tamalpais High School opened in 1908. Its 64 students from Sausalito and Mill Valley had their first class in a one-room shack with a canvas roof. Their principal was Ernest Everett Wood.

Ernest was born in a covered wagon in Kansas and moved with his family to California as a child. He attained his college degree from the University of California, Berkeley while supporting himself and his widowed mother as a carpenter. "He was a man of vision, integrity, and courage," wrote foreign language teacher Vera Stump. Ernest Wood oversaw Tam High for 36 years, shepherding it from a one-room school to a magnificent college-like campus. He introduced many innovative programs to the high school, and created a welcoming environment for students from diverse communities. His speech to the first class of Tam High students in 1908 captured his essential values: "You young people play the game square." E.E. Wood is seen sitting in the center of the first row in the above photograph from 1911. (Both, courtesy of Tamalpais High School.)

Chuck Smith, Teaching Understanding

On January 3, 1990, Chuck Smith, a history teacher at Tam High for 18 years, asked his second-period students to take their seats and quiet down. Chuck then began the final lesson of the popular teacher's career; he told his students that he was gay, had AIDS, and was dying. He also said he would soon be leaving school. He went on to lead a discussion on beliefs and myths about homosexuality, and about his illness, stressing that the use of condoms could protect against the deadly virus.

Chuck had already informed Principal Barbara Galyen and Supt. Walt Buster of his illness, and on this morning, he informed Galyen that his recently elevated symptoms confirmed to him that the time to resign had come. But he wanted to do it publicly, he said, so the students could learn from his experience. Galyen and Buster had already confirmed that Chuck's illness posed no threat to students or staff. They had told Chuck he could continue teaching as long as he wanted. Now, Galyen agreed to Chuck's request, and she attended the second-period class with him.

Chuck had worried about how students and parents would react to his news, but he also hoped to generate a positive dialog about the subject of AIDS. On that Tuesday, and the following Wednesday, his best hopes were realized. Most of the students had no idea that Chuck was gay, and boys, in particular—who had harbored antigay biases—suddenly found themselves questioning their previous beliefs. Tearful students hugged Chuck, and parents called the school to share their support for him and their gratitude for the ethical way that the school had handled the issue.

In the weeks and months to come, Tam High would host an AIDS Awareness Week. It would later become one of the first high schools in the nation to dispense free condoms to students who had parental permission.

Speaking in a newspaper interview, Principal Gaylen praised Chuck. "He had incredible courage," she said. "He wasn't just going to slink off into the night and die without telling [the students]. He gave a lot of kids a different perspective on . . . being homosexual in this society, and on the tragedy of AIDS." On Wednesday night, January 4, 1990—fewer than two days after his announcement—the consummate teacher died in his home. (Courtesy of Tamalpais High School.)

Dan Caldwell, Theater Teacher

When Tam High principal Bob Prather recruited Dan Caldwell in 1962 to teach English and drama, he knew what he wanted: A four-year sequential drama department. Dan, a former Tam High student, had achieved a good deal of success in films and theater by 1962, including work with Woody Allen and Otto Preminger, and a directorship at the Marin Shakespeare Festival. From Dan's first direction of students in *The Crucible*, Principal Prather knew he had made a good decision. By 1964, Dan was a full-time drama instructor. In the following years, he created two popular theater programs, the Summer Drama Workshop and the One Act Festival. He also took advantage of his professional connections to bring in talented volunteers and guest artists to assist in the production and direction of plays and musicals. Many people deserve credit for their roles in building that outstanding drama department. Among them was Susan Brashear, who joined Tam in 1996 as a part-time drama teacher and is now the codirector of Tam High's drama program. Another was student teacher Michelle Swanson.

In the late 1970s, Dan expressed a belief to Michelle that she took to heart. He told her that anything the drama teachers were doing that the students could be doing themselves deprived the students of an opportunity to learn. In 1979, while Dan took a sabbatical, Michelle Swanson started an after-school drama program that she called the Ensemble Theatre Company—with all aspects of production done by the students. When Dan returned, he embraced the program. Dan and Michelle sought funding for their idea, which required them to register their project as an incorporated nonprofit. Their first grant came from the Buck Foundation (later known as the Marin Community Foundation). Future funding came from many sources, including the National Endowment for the Arts. While the Ensemble Theatre Company (ETC) functioned as a separate nonprofit, students did receive class credit for participating. From those early beginnings, Tam's current Conservatory Theatre Ensemble eventually developed. The first ETC board chairman, John Cleaveland, said, "Many kids found a home [there] . . . I believe it saved many kids." One kid who took full advantage of the program was John's son Ben, who would become a professional actor and then, like Dan, return to head up Tam High's drama department. Dan retired in 1999 and continues a career in theater. (Courtesy of Ben Cleaveland.)

Ben Cleaveland, Picking Up the Legacy

In 2006, work was completed on the Dan Caldwell Performing Arts Center, a state-of-the-art theater on the Tam High campus. By then, Dan Caldwell had been retired for seven years, and the new codirector of the Conservatory Theatre Ensemble was former Tam High student Ben Cleaveland. Ben had grown up in Mill Valley and was a born thespian. As young as 10 years old, he had participated in local theater, including the variety shows put on by Dave Fromer and Rita Abrams. He even acted in a television pilot that they had produced. By the time he arrived back at Tam High as a teacher, he had a distinguished professional theater resume. He took the reins of an impressive program, which included a curriculum of drama arts, beginning drama, stagecraft, theater production, and directing. The Conservatory Theatre Ensemble (CTE) produces numerous full-length and one-act plays during the school year. The program attracts students from across Marin County and San Francisco. Under the guidance of Ben and codirector Susan Brashear, CTE continues to garner awards and prizes from education and theater organizations. (Both, courtesy of Ben Cleaveland.)

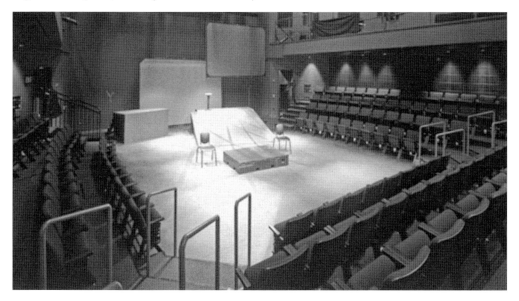

William Patterson, from Student to Activist
William Patterson entered the brand-new Tamalpais High School as a sophomore in 1908; he was the school's first and only African American student. Until that year, William had been living in Oakland with his mother—a former slave. When William's mother took a job as a live-in cook for a woman in Sausalito, she and William moved to their new home and William began school at Tam High. William soon found himself facing bigotry from his classmates. Two teachers at the school—Elizabeth Keyser and Alfred Guillou—showed William great compassion, something he would recall years later in his autobiography. With encouragement from Miss Keyser, William became an editor for the student newsletter and the 1910 school yearbook.

William Patterson went on to earn a law degree and become an outspoken voice against racial and social injustice. In 1951, he and fellow activist Paul Robeson presented a paper titled *We Charge Genocide* to the United Nations, accusing the United States with criminal failure to take action against race-related lynching. His autobiography, *The Man Who Cried Genocide*, was published in 1971. (Courtesy of Tamalpais High School.)

Tamalpais High School Students, Ambassadors of the Greater World
Tamalpais High School's student body includes residents of nearby Marin City. Marin City was originally constructed to house employees of Marinship, a shipbuilding company set up in Sausalito during World War II. Many of Marinship's workers were African Americans who came from places like Arkansas and Mississippi. These workers found that the Bay Area offered them a better life than did the poor and segregated states from where they had come, so they remained after the war. Eventually, permanent housing replaced the temporary wartime quarters, and African American families in Marin City became multigenerational. This connection gives Tam High a population more racially diverse than Mill Valley itself. During the civil rights era, racial tension grew at the high school, but it ultimately led to increased understanding. Since then the students of Tam High have often been the voice for the world beyond Mill Valley's borders. (Courtesy of Suki Hill.)

Rick Misuraca, Mill Valley's Gardener

Rick Misuraca prefers to call himself Mill Valley's gardener. For 30 years, and under a variety of titles, Rick supervised the development and maintenance of all Mill Valley's parks, playgrounds, public spaces, median strips, and its cherished and abundant trees. But to leave it there is to tell only a fraction of Rick's story of service to his hometown.

Born in Mill Valley in the 1950s, Rick grew up spending weekends in his grandparents' apartment over their bakery (Meier's) in Mill Valley's downtown. He raced his bicycle through Mill Valley's alleyways and across the still undeveloped pastureland in his Strawberry Point neighborhood. By the time he was a teenager, he knew every hill and canyon in Mill Valley. A high school teacher got Rick involved in a garden-restoration project that led to a lasting love of horticulture. In 1983, Rick took his first job for the city's park department.

During Rick's tenure, he converted the city's gardening practices to pesticide-free, reclaimed-watering techniques. When he saw how many of Mill Valley's fallen trees—particularly redwood trees—were being carted away, unused by the city, he set up a mill to produce local lumber for the building and repair of town fences, bridges, benches, and stairs. And what could not be made into lumber became mulch. Rick searched for common ground when conflicting groups fought over how best to use available public land; his motto was always, "I'm going for a 'win-win-win' solution," which he usually achieved.

Perhaps the most visible example of Rick's can-do attitude and vision is the Old Mill. John Reed's c. 1834 mill, for which the town is named, had been rebuilt in 1925, and repaired a number of times after that. But each repair took the mill further from its original design. By 1985, very little of the original landmark remained, and many city staff members recommended it be condemned. But Rick convinced the city council to save it. He then did exhaustive research on John Reed and his mill. By 1991, Rick had succeeded in getting the mill restored to its original design, with one significant difference—when building the roof beams, Rick did not use logs from redwood trees that had a core, or "pith," running straight down the center, as John Reed had done. Rick used logs with a different type of pith, one that is considered more structurally stable, and likely to last longer. There is some poetic justice to the fact that such a core is called "Free of Heart," the perfect term to describe Rick Misuraca. (Author collection.)

Doug Dawson, Opening Up City Hall

Pictured in the center, with Mill Valley resident Don Solem to the left, is now-retired city manager Doug Dawson. Doug served Mill Valley from 1982 to 1999, and remains one of the city's most admired city managers. Many considered him a mentor and praise him for making city hall more open and responsive to its citizens. (Courtesy of Penny Weiss.)

Jim Wickham, a Family of Service

One of three siblings, retired police captain Jim Wickham comes from one of Mill Valley's oldest families, some of who have served the town. His father, George, was mayor in 1964, and his sister Stephanie Wickham Witt is a town booster with a successful business in Mill Valley. Jim recently became a grandfather, placing the Wickhams in the "six generation Mill Valleyans" category. (Courtesy of the *Mill Valley Herald*.)

109

Ove Johnson, Volunteer Firefighter
In 1940, Homestead Valley resident Ove Johnson watched his home burn to the ground while county firefighters did nothing to stop it. They were only there to prevent fires from spreading, they told the frustrated Johnson. In response, Ove retrofitted an old Hudson into a fire truck and parked it in his front yard, creating the Homestead Valley Volunteer Fire Brigade. In 1950, a firehouse was built, the site of today's Volunteer Park. (Courtesy of Chuck Oldenberg.)

Mill Valley's City and County Firefighters, Saving Lives
Today, Mill Valley is served by a cooperative effort of city and county firefighters. The town's lack of summer rain, combined with an abundant fuel load of redwood trees and chaparral, make their job challenging. But there is another challenge. Mount Tamalpais's narrow road, which snakes around boulders on one side, and has a dead drop on the other, has been the scene of numerous accidents. The many people who have been rescued from a car crash on Mount Tamalpais say they will never forget the name of the firefighter who pulled them to safety. (Author collection.)

Officer Ed Johnson, Tenacious Ticketer
Though generally law-abiding, Mill Valleyans lived in minor fear of Officer Johnson. The tenacious ticketer drew notoriety for his stealthy invisibility until you sped down Sycamore Avenue or made a "California Stop" (slowly coasting through a stop-signed intersection). By the time the legendary motorcycle cop retired, half of Mill Valley's driving-age citizens had raised their hand in traffic school when asked, "How many of you got your citation from Officer Johnson?" (Courtesy of Suki Hill.)

Officer Ellie, World's Nicest Parking Enforcement Officer
"Nice" is not always the first word that comes to mind when people think of parking enforcement officers, but it is the best word to describe Officer Ellie, Mill Valley's senior PEO. Ellie's girlish braids and disarming smile are her major weapons against angry parking violators who find her ticketing their cars for expired meters and loading zone infractions. Friendlier locals take the time to engage Ellie in a little small talk and to enjoy her infectious laughter. (Courtesy of Suki Hill.)

Mill Valley's City Councils and Staff, Giving Back to the Community
Acknowledging all the people who have served Mill Valley in city hall would require a separate book, but this reunion photograph captures a few. All but one are former city council members. Included in this photograph is Joan Boessenecker, widely credited for engineering the greenbelt of open space between Mill Valley and its northern neighbor of Corte Madera. Pictured are, from left to right, (first row) John Leonard, Gary Lion, and Cliff Waldeck; (second row) John Jaeger, Flora Praszker, Betsey Cutler, Cathy Barnes, Alison Ruedy, Joan Boessenecker, and Kathleen Foote; (third row) Dennis Fisco, David Raub, former city manager Doug Dawson, and Dick Spotswood. (Courtesy of Kathleen Foote.)

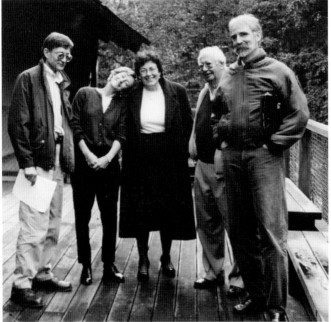

Anne Solem and Anne Montgomery, Growing the Library
In 1998, library board member Anne Solem and librarian Anne Montgomery witnessed the reopening of Mill Valley's beautiful library after a substantial expansion. The two had stewarded the project from its inception. Anne Solem was later elected to the city council and Anne Montgomery served as city manager. Pictured here on the library deck, which overlooks a grove of redwood trees and Old Mill Creek, are, from left to right, Don Dickenson, Anne Montgomery, Anne Solem, Lee Charette, and Bob Hatfield. (Courtesy of Anne Solem.)

CHAPTER SEVEN

Grist to the Mill

Though Mill Valley never had a mill in the commercial sense, or any industry, it has always had industrious people running businesses and catering to the needs of visitors and locals.

Mill Valley's first businesses were the dairies that delivered milk and eggs to people's homes. But well into the second decade of the century, few people actually lived in the town. For locally owned businesses, the biggest market was tourism.

In 1911, the Hiker's Retreat was established, offering showers and storage facilities for day-trippers who came to enjoy a day on Mount Tamalpais. Those who preferred not to walk could rent a burro from the Mill Valley Burro Company or ride to the mountain peak on the scenic railroad. Mill Valley had a large selection of hotels and inns, as well as camping grounds.

Into the 1980s, saloons did well in Mill Valley. Four saloons are still fondly remembered—Jimmy Quinn's, the Old Mill Tavern, the Office, and the 2a.m. Club (originally called the Brown Jug). Jimmy Quinn's closed in 1975, the Office became Sweetwater before finally shutting its doors, and all that's left of the original Old Mill Tavern is a sign hanging in Mama's Royal Café. (The Old Mill location, however, is now home to Vasco's Italian restaurant.) Of those four illustrious watering holes, only the 2a.m. Club is still in business.

Before the automobile became ubiquitous, Mill Valleyans shopped at local groceries, shoe shops, bakeries, and general stores. But today, Mill Valley's retail businesses face the same challenges that any local, independently owned business faces in this era of malls, websites, and national chains. On the other hand, Mill Valley has launched a few chain stores—both Banana Republic and Smith & Hawken had their first store in Mill Valley—and new stores are sprouting national roots from their Mill Valley home base.

Certain Mill Valley businesses have managed to weather all the changes in the world of commerce, and remain big supporters of the town's traditions—businesses like Mulugani Tire Center, a family-owned Mill Valley business for 65 years and big supporter of Mill Valley Little League (see page 82).

This final chapter includes some of those businesses. Most have been in place for at least 20 years. One or two have not quite hit the 20-year mark yet, but their odds are good. And one of Mill Valley's most beloved local businesses has been run by the same family for more than 84 years.

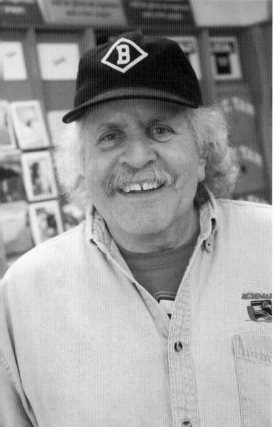

El Paseo, Edna Foster

In 1936, Outdoor Art Club member Edna Foster got tired of looking at what she considered an ugly building at 15 Throckmorton, so she bought it and some adjacent property, and transformed it all into El Paseo. The collection of apartments, businesses, a restaurant, and an outdoor art exhibition space was arranged to look like a Spanish passageway. To give it authentic old-world charm, she incorporated adobe bricks from Mexico, wooden beams from Fort Cronkite, and railroad ties and spikes from the Mountain Railroad. She even had the pathway designed with a natural slope toward the center to suggest years of foot traffic. Today, El Paseo functions very much as it did then. (Author collection.)

Two Neat, Bob Bijou

Bob Bijou has owned Two Neat for 26 years, and Mill Valleyans depend on the eclectic shop for must-have gift items like bacon-scented air freshener. The store is irreplaceable because of Bob's large selection of CDs and greeting cards that feature the work of local artists. (Courtesy of Suki Hill.)

**La Ginestra,
Tino and Maria Aversa**
La Ginestra opened in 1964. Though updated now and then, it maintains the same cozy, family-run feeling that Salvatore Aversa and his wife, Maria, created when they first opened their restaurant. Now managed by Maria and her son Tino, La Ginestra continues to offer the delicious Italian "comfort foods," like pasta with clam sauce and chicken cacciatore, that have kept locals coming back for more than 50 years. (Courtesy of Suki Hill.)

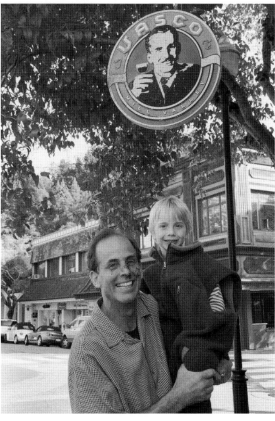

Vasco, Paul Lazzareschi
It is hard to believe that Vasco restaurant has only been at the corner of Throckmorton and Miller for 16 years. Owner Paul Lazzareschi, who personally greets customers at the door, is such a familiar face to locals that it seems the Italian restaurant, named after his father, has always been there. Perhaps Paul's son, also named Vasco and pictured here in his father's arms, will carry on the family business one day. (Courtesy of Suki Hill.)

115

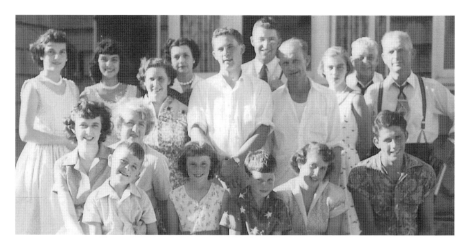

Mill Valley Market, the Canepa Family

When Frank Canepa decided to remain in Mill Valley, even after the 1929 fire threatened both his business and his life, he had no idea what an important decision he had made. Just a few years later, many Mill Valleyans, paralyzed by the Great Depression, would be forever grateful to Frank and his wife, Kaethe, for providing groceries on credit or trading them for services such as carpentry and medical care.

Frank and Kaethe had three children, Jim, Marilyn, and Bob. The Canepa family grew to become a multigenerational Mill Valley family (pictured above). Frank and Kaethe's sons eventually took over the running of the store from their father. Today, Jim's sons Doug and David own the store, and their kids also put in hours there. The Canepas' generosity continues. Bob, in particular, has received many awards for his work to help Kiddo and the Redwoods, among many other causes. And it is possible that none of that would have happened if Bob's mother had not decided to extend a European visit with Frank and six-year-old Bob (pictured below). They had been scheduled to leave on a return trip to America on July 17, 1956, aboard the same ship they had sailed over on, the *Andrea Doria*, which sank on July 25 during its return voyage. (Both, courtesy of Bob Canepa.)

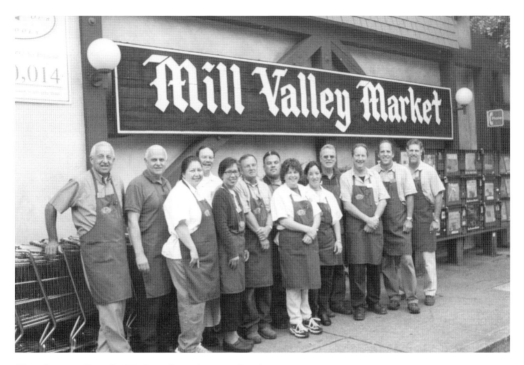

The Canepa Family Today, Growing the Business

Frank Canepa took great pride in his quality produce and his ability to get products into the store that were found nowhere else in Marin. So it would give him great pleasure to know that his grandsons Doug and David (pictured left to right in the bottom photograph) run an organic farm in Sonoma County to ensure that their market always has Frank Canepa–quality produce. As for unique, they have that covered, too. The store is well loved for its broad selection of gourmet items. The store has also partnered with the Mill Valley Chamber of Commerce to continue the popular Wine and Gourmet Food Festival that their dad, Jim, began in 1981. Jim is at the far left in the group photograph in front of their store; brother Bob is beside him. David and Doug are on the far right. (Above, courtesy of Suki Hill; below, courtesy of Gary Ferber Photography.)

Lorraine and Phil Adams, Mill Valley Coffee Shop
The Mill Valley Coffee Shop—owned and operated by Lorraine and Phil Adams since 1986—first opened in the 1930s as the Locust Avenue Café. In the 1970s, then Mill Valley resident and playwright Sam Shepard was regularly spotted enjoying coffee and a newspaper at a window table. The old-fashioned eatery remains a gathering spot for locals and visiting thespians alike. (Author collection.)

The Dipsea Café, John and Cori Siotos
John Siotos (pictured) and his wife, Cori, opened the Dipsea Café in Mill Valley's El Palseo in 1986. In 1991, they moved the restaurant to its current location at the edge of a tidal waterway in Tamalpais Valley. The café is named after the Dipsea trail, and its décor of Dipsea Race memorabilia nods to the long-gone Dipsea Inn, where hikers and runners once revived themselves after a day on the mountain. But today, it is not just mountaineers who enjoy the Dipsea's bountiful menu and wonderful view of the wetlands outside the picture windows. (Author collection.)

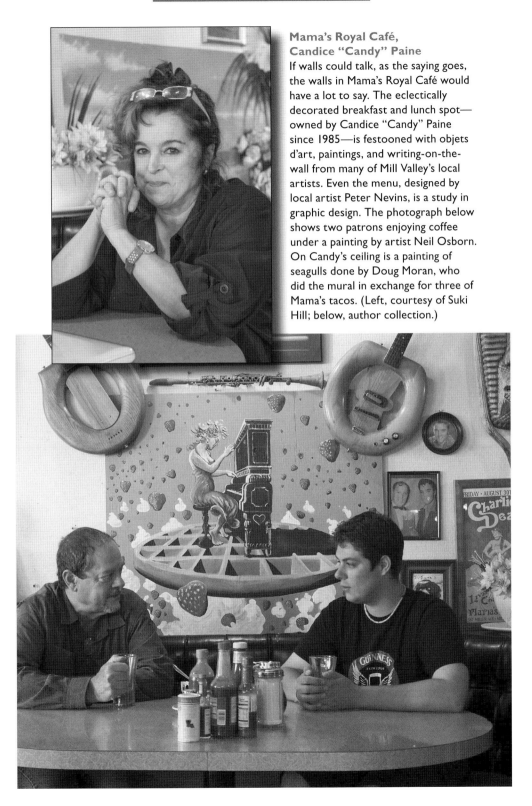

**Mama's Royal Café,
Candice "Candy" Paine**

If walls could talk, as the saying goes, the walls in Mama's Royal Café would have a lot to say. The eclectically decorated breakfast and lunch spot—owned by Candice "Candy" Paine since 1985—is festooned with objets d'art, paintings, and writing-on-the-wall from many of Mill Valley's local artists. Even the menu, designed by local artist Peter Nevins, is a study in graphic design. The photograph below shows two patrons enjoying coffee under a painting by artist Neil Osborn. On Candy's ceiling is a painting of seagulls done by Doug Moran, who did the mural in exchange for three of Mama's tacos. (Left, courtesy of Suki Hill; below, author collection.)

Depot Bookstore, Mary Turnbull

The Depot Bookstore and Café is located in a former train depot owned by the City of Mill Valley. The city has leased it out to various vendors over the years, and it has been some form of a bookstore since at least the 1970s. When the lease came up for renewal in 1986, some wanted a fancy restaurant to take over the space, but the city council felt that Mill Valley did not need another restaurant as much as a casual café and good bookstore, so the lease was awarded to book publisher Bill Turnbull and his partner (and eventual wife) Mary Hall, a former Sausalito bookstore owner. The Depot is still a family-run business, and Mary (Hall) Turnbull remains involved. Her daughter Nicole Ricci oversees the day-to-day operations, and the café's longtime manager is Celso De Leon. (Left, courtesy of Suki Hill; below, author collection.)

Team PRO Event, Steve Bajor

In 1976, Steve Bajor (a Mill Valleyan since 1951) merged his fondness for music with his skill for organizing events to found Homegrown Productions in his hometown of Mill Valley. Homegrown organized events ranging from Huey Lewis concerts to the first windsurfing and snowboarding national tours. In 1993, Steve created his current business, Team PRO Event, Inc. He also partnered with Pacific Expositions to produce festivals and celebrations all over Northern California. Steve brings all this experience to his position on the board of the Mill Valley Fall Arts Festival, which he and his team produce every fall. (Author collection.)

The 2a.m. Club, "the Deuce"

The 2a.m. Club, Mill Valley's last remaining saloon, was the Brown Jug until 1939, the year the city passed an ordinance requiring that bars close at midnight. The Brown Jug was outside the city limits, so the owner changed the bar's name to advertise that it was open until, well, 2:00 a.m. "The Deuce," as it is sometimes called, has a storied past, but many of its most legendary tales come from the 19 years that it was owned by Steve Powers (left, behind bar) and Dirk Payne (right, behind the bar). They sold it to Dave Marshall and Amanda Solloway in 2010. (Courtesy Suki Hill.)

All Wrapped Up, Lisa Walsmith
Lisa Walsmith has owned the gift and stationery store All Wrapped Up for more than 24 years. She is the closest thing Mill Valley's downtown has to a postmaster, because All Wrapped up is also a mailing center. On most days, Lisa can be found behind the store's counter talking with the locals who congregate to mail packages and share news. Out-of-towners also benefit from the store, which functions as the weekend satellite for the Mill Valley Chamber of Commerce Visitor's Center. (Courtesy of Suki Hill.)

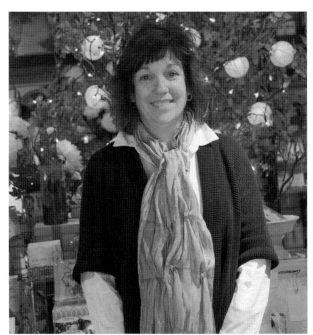

Ideal Stationers, Ron Clare
"Oh how do I love thee, let me count the ways," says one loyal Ideal customer. The Strawberry neighborhood store opened in 1968, and Ron Clare has owned it since 1984. Every September, parents holding shopping baskets of back-to-school supplies overrun the compact store. Ideal is treasured, in part, because of its late hours. It is not uncommon for a mother to burst through the front door at 8:00 p.m. in search of the "googly eyes" that her child just told her he needs for an art project due the next day. (Courtesy of Ron Clare.)

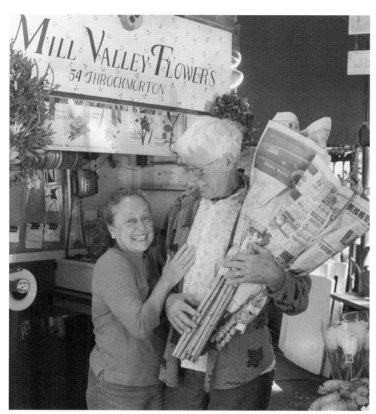

Mill Valley Flowers, Lars and Annabella Eriksson For more than 30 years, Mill Valley Flowers has been next door to the Mill Valley Market. Not only do owners Lars and Annabella Eriksson run an exceptional flower store, they also decorate the street with floral displays that recall European street markets. Their arrangements of peonies, hydrangeas, and roses spill onto the sidewalk from their outdoor shop, which is situated on the edge of Corte Madera Creek. (Courtesy of Suki Hill.)

Vintage Wine and Spirits, Richard Leland Vintage Wine and Spirits has been in Mill Valley since Prohibition ended in 1933 (though not always with that name). But when Richard Leland bought the shop in 1996, it became more than a liquor store. The former president of Jepson Vineyards winery applied his encyclopedic knowledge of fine wine and spirits to create an excellent source for hard-to-find wines and small-production liquors, and an educational resource for everyone from wine neophytes to connoisseurs. (Courtesy of Suki Hill.)

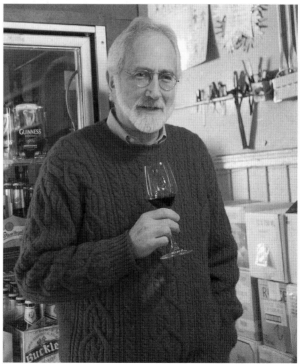

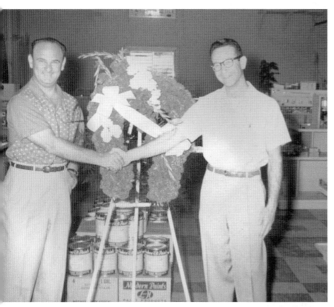

Goodman's Building Supplies, Ed Goodman and Richard Harris
Ed Goodman and Richard Harris shook hands on a new business 57 years ago. Ever since then, Goodman's Building Supplies has provided Mill Valleyans with everything from lumber and electrical supplies to potted plants and picnic tables. Harris's son-in-law Zviki Govrin now manages Goodman's, and the store still offers customers the items they have come to expect, including free warm popcorn from the popcorn machine at the customer service counter. (Courtesy of Goodman's Building Supplies.)

Tony's Shoe Repair, Misak Prinijian
Mill Valleyans are completely dependent on Tony's Shoe Repair, because the owner, Misak Prinijian, can fix anything. Though many people call him Tony, Misak says there has not been a Tony in the shop since his father bought it in the 1960s. Misak is the owner now. His friendly and patient personality—combined with his cobbler skills—has inspired many to refer to him as a civic treasure. (Courtesy of Suki Hill.)

BIBLIOGRAPHY

Anne T. Kent California Room, Marin County Free Library. *Oral History Project of the Marin County Free Library.*
Bancroft Library, University of California, Berkeley. *California Oral History Project.*
Binkey, Cameron. "A Cult of Beauty: The Public Life and Civic Work of Laura Lyon White", *California History.* California Historical Society, 2005.
California Digital Newspaper Collection (http://cdnc.ucr.edu/cgi-bin/cdnc).
Davis, Matthew and Michael Farrell Scott. *Opening the Mountain: Circumambulating Mount Tamalpais, A Ritual Walk.* Counterpoint, 2006.
Fairley, Lincoln. *Mount Tamalpais: A History.* Scottwall Associates, 1987.
Gidlow, Elsa. *Elsa I Come With My Songs.* Booklegger Press & Druid Heights Books, 1986.
Goerke, Betty. *Chief Marin: Leader, Rebel, and Legend.* Heyday Books, 2007.
Kelly, Nancy and Kenji Yamamoto. *Rebels With a Cause.* New Day Films, copyright 2010.
Killion, Tom and Gary Snyder. *Tamalpais Walking: Poetry, History, and Prints.* Heyday Books, 2013.
Lucretia Little History Room, Mill Valley Public Library. *Mill Valley Oral History Project.*
Marin Independent Journal.
Mill Valley Historical Society. *Mill Valley Historical Society Review.* Private printing, 1979 to 2013.
Mill Valley Herald.
Mill Valley Record.
Nicosia, Gerald. *Memory Babe; A Critical Biography of Jack Kerouac.* University of California Press, 1983.
Oldenberg, Chuck. *History of Homestead Valley.* Private printing, 2012.
Pacific Sun.
Patterson, William L. *The Man Who Cried Genocide.* International Publishers Co., Inc., 1971.
Ptak, Elisabeth. *Marin's Mountain Play.* Mountain Play Association, 2013.
Santos, Robert L. "Azoreans to California," *The Californians.* Volume 13, the University of California, 1995.
Spitz, Barry. *Mill Valley: The Early Years.* Potrero Meadow Publishing Co., 1997.
Wilson, Carol Green. *Alice Eastwood's Wonderland.* California Academy of Sciences, 1955.

INDEX

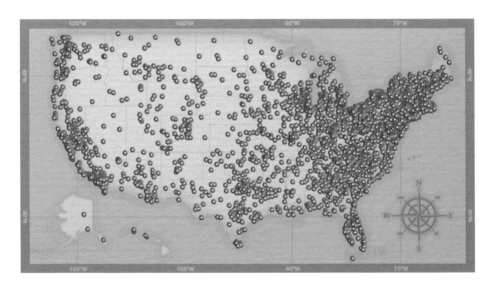